Photographic Lighting Simplified

Photographic Lighting
Simplified

Susan McCartney

ALLWORTH PRESS
NEW YORK

08 07 06 05 04 03 5 4 3 2 1

Published by Allworth Press
An imprint of Allworth Communications, Inc.
10 East 23rd Street, New York, NY 10010

Cover design by Joan O'Connor Graphics
Page composition/typography by Sharp Des!gns, Lansing, MI

ISBN: 1-58115-256-6

LIBRARY OF CONGRESS CATALOGING-IN-PUBLICATION DATA
McCartney, Susan.
Photographic lighting simplified / Susan McCartney.
p. cm.
Includes index.
ISBN 1-58115-256-6
1. Photography—Lighting. I. Title.
TR590 .M38 2003
778.7'2—dc21
2002015916

Printed in Canada

This book is designed to provide accurate and authoritative information with respect to the subject matter covered. It is sold with the understanding that readers will use utmost care when handling photographic lights or undertaking any photographic activity. While every attempt is made to provide accurate information, the author and publisher cannot be held accountable for errors or omissions.

Acknowledgments

Author photo © 2002 Karol DuClos.

Many people have helped with the preparation of this book.

Family members, friends, colleagues, models, students, and people who were once, but no longer are, strangers have all posed for pictures. Especial thanks to my daughter, Caroline Nye, and to Karol DuClos, Darren DuClos, Christopher Crawford, Daisy Little, Michael Moran, Jon Naar, and Pat and Wayne Fisher, all of whom helped a lot.

Some images were originally made for commercial clients—I thank them, too.

Manufacturers have loaned equipment, answered questions, and, in a few cases, supplied product pictures.

I have shamelessly picked the brains of people I met in person or online who are more expert than I on fine points about digital cameras, lighting for digital imagery, or preparing scans for reproduction. Thanks especially to Charlie Sharp, the designer of the interior of this book; Irwin Miller, the digital guru at Calumet here in New York; and to designer David Milne. I also thank Joan O'Connor, who designed the book's cover.

My lighting gurus over the long-term have been photographers Harold Krieger, in whose class I first learned to "see" and recreate light; also Bodi; Phil Leonian; Steve Manville; and strobe-maker Albert Nye.

Thanks as always to my publisher, Tad Crawford, who is ever supportive, and his lovely staff, including my editors Elizabeth Van Hoose and Kate Lothman and publicists Birte Pampel and Michael Madole.

Table of Contents

Introduction

This book is intended carry you from near-total ignorance about lighting to the intermediate skill level.

At first glance, the facts and techniques presented here might not seem so simple. Take it slowly—one step leads to the next. Each section is self-contained and can be read in any order. You should be able to quickly find how to light specific subjects by referring to the index.

I have tried to write in the plainest possible English about fundamentals of lighting for both film and digital media. The early sections cover safety with lights; how to choose and set up photofloods, quartzlights, strobes, and flashes; and how to meter and modify those lights.

Creating mood with light is all important, and time-tested approaches to lighting different subjects are demonstrated in detail. You will learn to be comfortable when shooting favorite subjects with your preferred lights, and also to challenge yourself and risk breaking rules when not under pressure, with the aim of enhancing skills and achieving a personal lighting "look."

Nine self-assignments give experience in lighting portraits and groups, still-life subjects, and interiors. These, plus a section on approaches to popular subjects, are for practice and later referral, and they will possibly help with first commercial jobs, too. The last section covers editing, displaying, and marketing work.

There is a troubleshooting guide, a resource list, and an index. Photographs within this book whose setups are not explained in the book proper are described in appendix C.

Lighting well requires experience and inspiration—progress rapidly by practicing and shooting with lights often. Look at great paintings and photographs, even classic movies and the best TV commercials, to improve your lighting "eye," too.

I hope this book helps you reach personal and professional goals, and I wish you success on your own terms. Thanks for reading it.

Susan McCartney
New York City

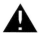 # Important Lighting Safety Information! Please Read Carefully!

- Never be afraid of using photographic lights, but always treat all of them with respect.
- Always read and follow lighting manufacturers' safety and operating instructions.
- Never run more than 1,200 watts total of lighting equipment off one modern AC power circuit.
- Never plug any lights or strobe power packs into AC power outlets where appliances that heat are on the same circuit.
- If your hotlights or power packs trip a household circuit breaker or blow a fuse, immediately turn off the lights or strobe packs before resetting. Then reduce wattage demand on the AC circuit, or split lights or packs between two or more circuits.
- Always use cotton gloves to touch glass, to prolong lamp and tube life.
- Never use frayed or damaged power cords or extension cords.
- Never use any lighting equipment where it's wet.
- Be aware that all photo lamps and tubes can burn fingers. Let them cool before packing.
- Never touch a tungsten lamp (bulb) or strobe tube while the equipment is turned on.

- Allow twenty minutes' cooling time before changing or packing lamps or tubes.
- Never allow children or animals to be left unattended near lights.
- When photographing kids or animals under lights, be sure a parent or baby minder or animal handler is on the "set."
- Warn adults that they must never touch lights, cords, or equipment.
- For maximum safety, use sturdy light stands. Extend stands from the bottom up. Make sure all stand sections are locked before adding lights or strobe heads.
- Weight tall stands at the bottom. "Booms"—light stands with an arm that extends to hang light over the set—require counterweights to keep them from tipping.
- Light cords must reach the bottom of stands and lie flat on the floor to reach the AC outlet—use extension cords if needed.
- For maximum safety, tape power cords to the bottom of stands and to the studio floor with electricians' "gaffer tape."
- Refer to these safety suggestions, and others in the body of the book, until they are second nature to you.

Lighting Overviews

A First Photo Setup

Lighting photographs is fun and will expand your photo opportunities to an enormous degree. To be able to use photo lighting is virtually a necessity for professional or would-be professional photographers (except, perhaps, for nature specialists).

To use lights in a controlled way, you need to have basic photographic skills: First, you must use a meter to read exposures (the amount of light present) and then be able to select and set appropriate shutter speeds on cameras and f-stops (apertures) on lenses.

Ideally, you should own a camera with fully user-adjustable controls—an all-manual camera is fine. A "program-only" film or digital camera is all right to begin lighting, as either can be used with some (not all) photo lights. Eventually, however, a program-only camera may limit your creativity. (Should you need a quick refresher on camera-handling skills, I suggest you read my book, *Mastering the Basics of Photography*, along with this one!)

In this book, you will learn to light popular subjects—people, objects, interiors, and more—from scratch, and learn to add light to scenes with some existing light already present. You will use studio lighting, of course, and also add lights when you want to create effects that daylight or available (existing) lights cannot.

Any uncluttered space about ten feet square, which can be darkened, is adequate as a first "studio." The ideal studio space should have an eight-foot or higher ceiling, so that you can raise lights up high. It should be painted white or gray; bright-colored walls, ceiling, or even floor can reflect unwanted color onto your subjects. The ideal studio should have two or more 110 volt electric power outlets, preferably on two different circuits.

Start lighting with any lights you presently own. If you are starting lighting from scratch, see my starters' equipment suggestions on page 11.

Keeping Track of First Lighting Setups

Before you begin to explore the infinite possibilities of photographic lighting, take a moment to sketch the floor space of your studio. I'm not a person who writes everything down, but I do find it helpful to keep notes when learning something new. The grid shown on page 4 represents a hundred-foot-square studio. You may duplicate it, or make a diagram of your own space.

Whenever you create studio lighting setups, note the film speed being used or the digital camera media speed set. Then, on your diagram, note subject and light placements and distance from subject, height of lights, where you put any reflectors, and anything else you want to remember. The diagrams do not have to be elaborate. Also note shutter speeds, lens apertures, and any exposure variants used—these specifics apply to both film and digital cameras. If you note what you do conscientiously, you should soon learn average light placements, shutter speeds, and lens settings needed for good lighting and exposures with your equipment.

Lighting Diagram and Notes

Subject **Date** **Released?**

Camera Film ISO Digital ISO

Light 1: Type Full ___ or ___ power. Aimed at: Height:
Light 2: Type Full ___ or ___ power. Aimed at: Height:
Light 3: Type Full ___ or ___ power. Aimed at: Height:
Light 4: Type Full ___ or ___ power. Aimed at: Height:

Modifiers: Light 1 Light 2 Light 3 Light 4

Notes:

EXPOSURE BY FRAME

1	19
2	20
3	21
4	22
5	23
6	24
7	25
8	26
9	27
10	28
11	29
12	30
13	31
14	32
15	33
16	34
17	35
18	36

One square = 1 ft. = 0.3048 m.

4

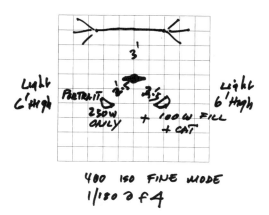

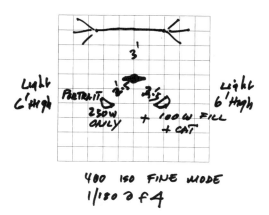 shows handwritten notes:

CAROLINE 3/18/02
PORTRAITS
ALONE + WITH CAT

3'
Light 6'High
Light 6'High
PORTRAIT
250W ONLY
+ 100W FILL
+ CAT

400 ISO FINE MODE
1/180 @ f4

A sample lighting diagram.

Basic Lighting Tools

At minimum, you will need one photo light fixture and a couple of adjustable light stands. If using a photoflood or quartz hotlight, keep a spare "lamp," or bulb, on hand.

If your camera does not have a built-in meter, a handheld light meter is essential. Also essential are a sturdy tripod that extends to your eye level and a portable "reflector" of some sort (it can be purpose made, or a 20×30 inch sheet of white and silver artists' illustration board).

Also get extension cords, a ceramic insert to place between the photoflood fixture and lamp, and a couple of "A" clamps from a hardware store. A roll of "gaffer" tape (film electricians' strong, easily removable fabric tape) has many uses in a studio; buy it at a photo dealer, and you'll have a complete first lighting kit. This information is repeated in greater detail later in the section.

My Other Relevant Books

My book *Mastering the Basics of Photography,* also published by Allworth Press, can be used as a "prequel" to this one if, to date, you have worked only with "point and shoot" film or digital cameras, or if your photo skills in general need a brush-up.

If you are interested in achieving studio-type lighting with small, battery-powered flashes, I do touch on that in this book, but you might also do well to read my *Mastering Flash Photography.* This is extremely thorough and illustrated in color. Amphoto/Watson-Guptill is the publisher.

My book *Travel Photography* covers lighting for overseas travelers.

If You Are Beginning Lighting with a Digital Camera

A high percentage of the images in this book were made on my Fuji S-1, a camera based on a Nikon N-60 body. I have just recently bought a Fuji S-2; it's shown on page 54.

One thing to be avoided when lighting for digital images is too much contrast—too-bright highlights tend to burn out, and too-dark shadows don't reproduce well. I keep the lighting fairly even. (In fact, very-high-contrast lighting is to be avoided when shooting film, too—for much more on this, see the section on Exposure and Metering, starting on page 40.)

I have found that photoflood and quartz hotlights are compatible with all digital cameras, even tiny program "point-and-shoot" models without user controls. Consumer digital cameras all have built-in flashes—turn the flash off when shooting under hotlights, if possi-

Canon's D-60 is the company's mid-priced 6 megapixel digital camera, a successor to its popular 3 megapixel D-30 model.

Nikon's D-100 is the company's first mid-priced 6 megapixel digital camera. Both of these models are designed to appeal to advanced amateur or professional photographers and have a street price of about $2,000 at the time of this writing.

ble (see the camera manual), or put black tape over the flash. When shooting under hotlights with any digital camera, set the "White Balance" mode to match indoor or tungsten light.

To use a detachable flash or strobe, your digital camera must have user-adjustable controls and either a "hot-shoe" on top or a "synch/pc" outlet on the side. Either can be used to connect a separate flash or strobe to the camera. (But see the caption below!)

Exposing with a Digital Camera

An obvious advantage of all digital cameras is that they are great learning tools. You measure exposure by aiming the built-in TTL (through-the-lens) meter at the most important part of a subject. You can hold focus and exposure by keeping the shutter button depressed halfway down while you recompose or "reframe" the scene if needed (see your camera manual). Always remember not to aim the meter at bright lights, or you will get underexposed images. Of course, with digital cameras, you can immediately play back and view images on the LCD screen, and correct exposure or improve light placement if needed.

Be aware that playing back images may degrade them, so don't overdo this. Playback mode also uses up batteries fast—keep spare batteries on hand.

My friend Jon Naar uses his 3.3 megabyte noninterchangeable-lens digital "point-and-shoot" Olympus Camedia for some professional jobs. With hotlights and camera on a tripod he relies on the built-in TTL meter to adjust exposure. (He has even used the built-in flash to fire a slaved Dynalite strobe aimed to light dark ceilings in big buildings, but says that this is not recommended for beginners—it takes a lot of experience and experimentation; then, with camera on tripod, Jon adjusts the strobe power to balance with the existing lighting, using the camera's playback mode as a guide until he gets it right.)

The Three Basic Types of Photo Lights

Photo lights can be broadly classified.

- **Tungsten**, or "hotlights," burn continuously, so effects are easy to see—photographers have used them for over a hundred years. The big lights used on movie and TV sets are tungsten lights, and so are the lights used in the theater, clubs, and at rock concerts. The tungsten lights used by most still photographers today are called "photofloods," or "quartz" lights. They are lightweight and of reasonable price and size. (Today, expensive so-called HMI hotlights are also popular with professional photographers, but those are outside the scope of this book).
- **Battery-powered portable flash units** can be tiny, compact, or moderate-sized, can be used on- or off-camera, are fast-acting, and emit brief bursts of light that can "stop" or "freeze" much action. They are the mainstays of most wedding, event, and news photographers and photojournalists.
- **"Strobe" lights** (originally called stroboscopic lights) are also known as "portable strobes" or "studio flashes." They can consist of a "power pack" plus one to four separate "light heads" connected to the pack by cords, or they can be "monobloc" or one-piece units. Strobes all run off a continuous electricity supply; incorporate a continuously burning tungsten "modeling lamp," so effects are quite easy to see; and when fired emit short, bright bursts of light that can stop much motion, as flashes do.

Strobes can fire every few seconds, almost indefinitely, and are the workhorses of many photography studios.

In the hands of the skilled, many effects can be created with all three types of lighting. It is sometimes difficult to know just by looking at a photograph whether the subject was lit by a hotlight, a flash, or a strobe.

As long as a subject is not too big and is not moving fast, the way a light is used has more effect on the lighting "look" of a photograph than does the type of light itself. Hotlights cannot "stop" or freeze fast motion. And any light "bounced" (reflected) out of a white umbrella down onto a portrait subject is quite soft—the bigger and closer the umbrella, the softer the effect.

I discuss what different types of light do best in the sections on hotlights, flashes, and strobes, later in this book.

Lights to Learn With

I highly recommend tungsten lights for learning studio-type lighting. Most are cheap or reasonably priced and are easy to set up. And, as mentioned earlier, they burn continuously, so lighting effects are easy to see.

Photoflood lamps can be used in big, metal reflectors; these can give pleasant effects when used close to a subject. But the lamps are somewhat fragile and the fixtures bulky, so I don't recommend photofloods for travel.

Quartz-type hotlights are compact and easy to transport; diffuse these lights for soft effects.

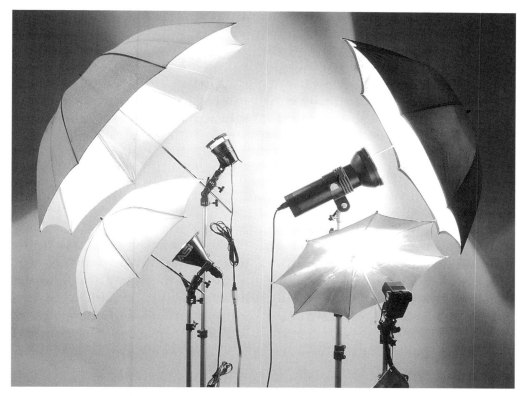

Lights from lower left clockwise: A photoflood in a 5-inch reflector, a Smith-Victor quartz light, a monobloc strobe unit, and a battery-powered flash. All are aimed into umbrellas. When so used, the quality of light from each can be similar.

Strobe Units

Learn studio lighting with strobes, too, if you are serious about photography and have access to a strobe. Readers with professional ambitions who have the budget can start learning lighting with a strobe unit. Such units usually consist of an AC-powered "pack" plus one to four "light heads" that connect to the pack by cables.

Monobloc strobe units are one piece. Cheap monoblocs can be had, but I strongly suggest that you buy monobloc strobes that are part of a good, professional strobe system. Accessories that fit light heads designed for the power pack will (for the most part) fit light heads of the monoblocs. I use the Profoto strobe system. Other excellent systems are Balcar, Calumet Traveller, and Elinch-rom. I also have a small, portable Dyna-Lite system, which is excellent for location photography.

Flash

I do not recommend using most small flash units to learn lighting. Although almost any battery-powered flash unit can, if used very close to a subject, be made to mimic studio lights, most do not have built-in modeling lights. So, it's hard for the inexperienced to preview lighting effects.

A few expensive, professional battery-powered flash units offer an optional AC-power adapter and an optional light head that incorporates a low-wattage modeling light. (For more, see the discussion in Battery-Powered Flash, page 72.)

A One-Light Lighting Kit

A tungsten lighting kit you can grow with will cost about $150–200.

For working in a studio-type space, I like photoflood lamps (bulbs) in good-size reflectors—Smith-Victor has marketed these for many years. Buy one or two photo light fixtures with ten-inch round metal reflectors, a couple of 250 or 500 watt photoflood lamps (bulbs), two adjustable light stands, and a twenty-four or thirty-six-inch collapsible, round, white/silver reflector from ProTech and others. Add a roll of electricians' gaffer tape, a grounded extension cord, and perhaps an "A" clamp or two. Get a $3 ceramic insert to put between lamps and fixtures from any hardware store, and you are all set to begin.

To start with one quartz tungsten light, buy either the handy-sized Smith-Victor 700-SG model or the professional Lowel Omni light. Both put out 600 watts of light.

With such an outfit and any electronic film or digital camera, or user-adjustable film camera, you can easily shoot portraits or still-life arrangements, figure studies, and people, and you can make clear shots and close-up details of objects to be sold on the Internet.

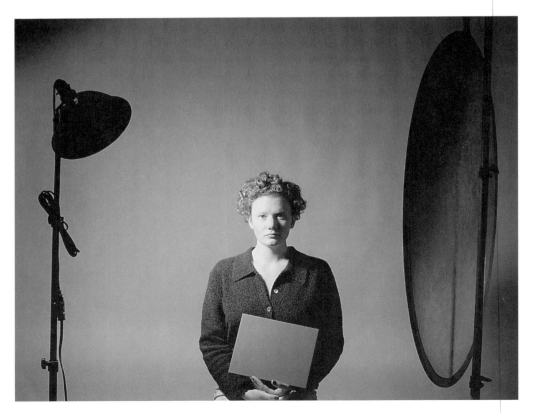

A one-light portrait setup with reflector.

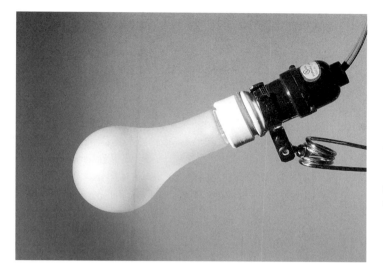

For safety, always use a porcelain socket extension between any photoflood lamp (bulb) and any photo or household light fixture. Mine, by Leavitt, cost $2.99 at my hardware store.

A Rock-Bottom-Budget First Lighting Kit

If you are cautiously dipping one toe into lighting, or if your budget is almost invisible, this hotlight kit will not break the bank. First, buy a "garage light" fixture with a reflector, a ceramic safety socket insert, an extension cord, and an "A" clamp from any hardware store. Together, those items cost me about $19 recently. A 250 watt photoflood lamp (code ECA) was $3.95, and a 500 watt lamp (code ECT) cost $4.95, both from my local Calumet professional photo store. (I recommend this company, both at retail and as a mail-order dealer— Calumet has an exhaustive free catalog illustrating almost everything photographic.) From this source, I also bought a roll of film electricians' easily removable gaffer tape for about $12. Two 20 × 30 inch sheets of silver/white artist's illustration board cost $5 at my art supply store.

Six-foot-high collapsible light stands are advertised in *Shutterbug* and other photo magazines, starting at about $25,

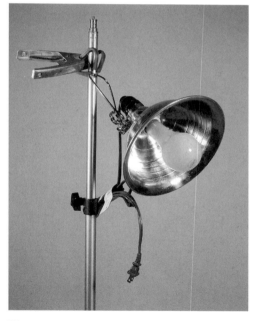

The most basic lighting fixture you can buy is a garage light, sometimes called a work light, which recently cost me $7 at my local hardware store. It's shown here with a 250 watt, 3,200°K photoflood lamp.

or they can be found used. I like sturdy Manfrotto stands, which start at about double that amount.

Complete your kit with a thirty-six-

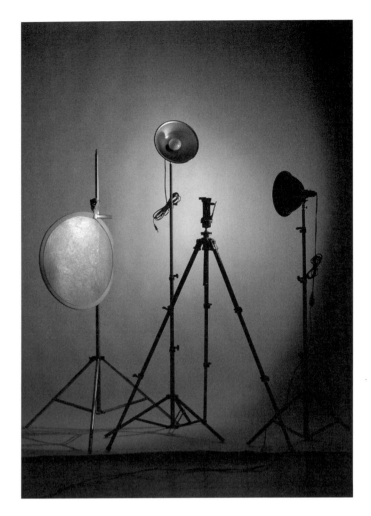

An excellent first lighting kit can cost you under $250. Shown are two 500 watt flood lamps in ten-inch Smith-Victor reflectors, two six-foot and one eight-foot light stand, a white/silver collapsible Photoflex reflector (I own several in different sizes), and a sturdy tripod that extends to eye level. One of my favorite tripods is this Manfrotto number 3025 model fitted with a number 3265 grip-type ball head.

inch white translucent "shoot-through" umbrella (from $20–25) and a ProTech umbrella clamp ($20). Get them at Calumet or other photo dealers.

Aim the garage light directly, or soften the light by shining it through the umbrella. In either case, aim light down onto your subject. A 45-degree angle is a good place to start.

This kit will be very adequate for first studio portraits, still lifes, or for lighting objects to sell on the Internet.

Move the garage light to your workshop or basement for another use when you upgrade to more sophisticated photo lighting equipment. I have one over my computer!

How Tripods Help Lighting

A sturdy tripod is a wise photographic investment, and no serious photographer works without one. I like the Manfrotto, Gitzo, and Slik brands. Ideally, a tripod should be tall enough to reach your eye level while you stand.

Setting the camera on a tripod will help you "compose" (frame) subjects accurately with any lighting setup. Of course, use of a tripod also prevents camera blur when you must use slow shutter speeds under any lights. This is frequently necessary when small lens apertures must be set for good depth of field (zone of sharp focus)—for still lifes, for instance.

Thinking about Light

You will quickly improve your ability to create and recreate lighting effects you like if first you take time to study natural light.

Hard Light

- The sun is the source of all daylight—sun in a clear sky casts one hard shadow opposite each object it hits.

- The angle and length of that shadow depends on the angle of the sun to the earth, as well as to the subject.

- When the sun is overhead, shadows are short; when it is low, shadows are long.

- When the sun hits the side of a subject, it reveals texture.

- Light that casts a hard shadow is technically known as "spectral" light.

- Hard light can be dramatic in effect, or it can be harsh, ugly.

- Any photo light with a metal reflector mimics the look of the sun in a clear sky, causing a hard shadow to fall behind whatever it hits.

- The angle, shape, size, and finish of metal reflectors behind lights, when aimed directly at a subject, all influence the "look" of the light.

- A "bare bulb"—a photo lamp, flash, or strobe tube without a reflector—casts a soft shadow similar to the sun through thin clouds or mist.

Soft Light

- The sun filtered through fog or cloud casts soft shadows or almost no shadows.

- Soft light, called "diffused" light, is easy to use, flattering to most subjects.

- Totally shadowless light can be flattering, or dull or drab, like the light of a heavily overcast day.

- The sun, when it "bounces" (or reflects) from a white wall onto a nearby subject in shadow creates a warm, flattering, almost shadowless effect.

- Photographic light can also be softened by "bouncing"—reflecting—it. Bounced photographic light is always soft and is usually flattering to people.

- Many accessories are made that diffuse and/or bounce photo lights—white umbrellas and collapsible white/silver reflectors are the most useful.

Setting Up Your First Light or Lights

Do not be intimidated when starting lighting, but, of course, proceed carefully. Read and follow the manufacturers' instructions with lights. Before you start, reread "Important Lighting Safety Information" on page xi.

To begin, locate (female) mounting fixture on the light or strobe head, and carefully mount the light on the (male) stud on top of an adjustable light stand. Tighten the light fixture nut until it holds the stud firmly.

Raise any light stand one section at a time, starting at the bottom. Tighten each section nut before raising the next, until the stand reaches the desired height—about six feet is good for a sitting adult, or two feet higher for a standing one.

Use an extension cord to reach the outlet, if needed. Power cords must always lie flat on the floor. Weight the bottom of stands if using heavy light heads.

Tape cords to the stand and to the floor if children or animals are "on the set" or near it.

Check that everything is secure and that the light fixture or strobe head is turned off before plugging the fixture into an AC power outlet.

Let photo lamps or strobe heads cool before changing or packing them. To prolong lamp life, use tissue or gloves when handling them—oil residue from fingers shortens lamp or tube life.

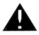 Important Safety Reminder

If you raise any light stand to its maximum height, always weight the bottom for safety. Use a purpose-made photo weight or a bag filled with sand or stones. Use gaffer tape to attach light cords to stands, and be sure to use an extension cord long enough for the cord to lie flat on the floor all the way to the AC outlet. Gaffer-tape the cord to the floor if you are working with kids, animals, or a crowd. Never plug a light into any circuit where devices that heat or cool are in use. No more than 1,200 watts total should be plugged into any modern electric power outlet. Older buildings may have less capacity.

Upgrading from Rock-Bottom-Budget Lights

As I have already written, you can begin serious lighting with one floodlight, an adjustable stand, a garage light fixture with clamp and reflector, and a few accessories for a rock-bottom $50 (see page 11). The price for basic items can rise to around $100–150, if you buy a purpose-made photo light. For around $150 to $200, you can buy one quartz light fixture, plus a stand and a few accessories.

Strobe power is measured in watt-seconds (WS) in the United States, or in equivalent joules (J) in Europe. I suggest buying a first monobloc strobe of no less than 300 WS/J, or a first power pack of no less than 500 WS/J, plus two light heads.

Moderately priced strobe brands with a good reputation are Novatron, Photogenic, and White Lightning. Calu-met, Comet, and Dyna-Lite are good mid-priced brands. Expect to spend about $1,500 and up for a 1,000 WS/J strobe pack plus two light heads. Profoto is an upper-mid-price brand with many accessories. Profotos and top-brand strobes like Balcar, Broncolor, and Elinchrom with extensive systems are quite to extremely expensive. But you get what you pay for—all are great systems.

You can get "no-name," low-power monobloc strobes for a couple of hundred dollars. Avoid these often-unreliable units. Good new monobloc strobes cost around $600 each. Good strobes can easily be found used, and as most are not extraordinarily high-tech, a used strobe is a reasonable proposition.

My cat, Orby, likes getting into pictures, as you can see elsewhere in the book. Here, I lit her with a 250 watt photoflood in a garage light reflector. The light was aimed from about 3 feet from the side and 4 feet above her; the high, three-quarter lighting emphasized the texture of her fur.

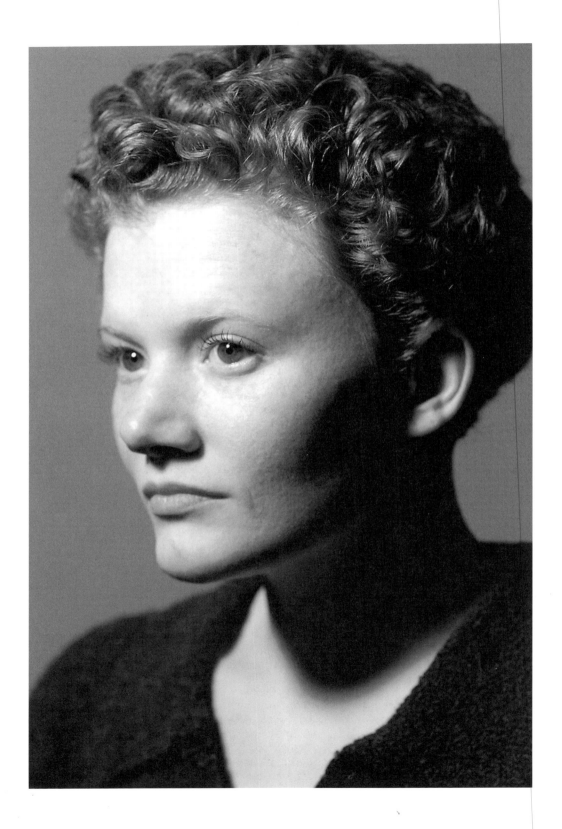

A hotlight was bounced off a sheet of white artboard taped up at subject's left to make this portrait. I used an 80mm lens and camera on a tripod and ISO 100 film. Exposure was $1/30$ at f/5.6.

BUYING USED EQUIPMENT

I suggest trying to find used equipment and accessories at good local photo dealers. Then you can check out and, if necessary, return purchases easily.

Sometimes you can't find what you want that way, or are far from a good dealer. Then check reputable mail-order dealers and their Web sites; many sell used items. Again, of course, be sure you can return items.

Sometimes, good buys and hard-to-find items can be located on Internet auction sites. I have sold a few items on eBay, listing my real name, so people know I stake my reputation that the item will be as described.

If you choose to buy lights, stands, meters, and so forth, sight unseen off the Internet, be sure to check the reputation of the seller. Feel free to ask for precise descriptions of the condition if you have any doubts, and be sure that items can be returned if there are problems. Then you may well be pleased.

LEFT: I imitated Hollywood-style lighting with one 250 watt, 3,200°K ECA photoflood lamp in a ten-inch Smith-Victor reflector with a soft aluminum finish. The model was three feet in front of a light gray background. The light was placed at "high three-quarter" position, about two-and-a-half feet to the front and left of the model, six feet high and two feet above, and aimed down at her head. I used an 80mm f/1.8 Nikkor lens. The ISO setting on my Fuji S-1 digital camera was 400; exposure by the in-camera meter was $1/180$ at f/4. The camera was on a tripod. I took about twenty shots; this is my favorite.

 # Basic Lighting Tips

- Your first studio light can be a photo-flood lamp (bulb) in any metal reflector. The bigger, the better—nine or ten inches is a good size.

- Or it can be a quartz hotlight or a strobe head if your camera is adjustable and has a strobe "synch" outlet (see camera manuals).

- Both quartz fixtures and strobe heads usually have five- or six-inch reflectors.

- The "look" of a light comes from the size of the reflector, the light's angle and distance to a subject, and whether it is aimed directly or softened.

- The brightest light in a setup is called the "main" light. One light in a polished metal reflector creates distinct, deep shadows. Effects vary according to size and finish of the reflector.

- Extremely high-contrast lighting is normally undesirable with film or digital images.

- With one light, place a collapsible fabric photo reflector, or a 20 × 30 inch white or silver sheet of artists' illustration board, opposite the main light to reflect or "bounce" light and lighten or "fill" shadowed areas.

- With two lights, place the second opposite the main light but further from the subject, to lighten shadows. This is called the "fill" light.

- With two lights, place them to avoid "crossed" or double shadows.

- Place a main light so that it shines down from about two feet above and two feet to the right or left of a subject or object. This almost foolproof, "high three-quarter" light flatters almost anyone or any subject.

- Use a reflector or fill light at the same height as the main light to lighten shadows.

- Experiment with your one light or with two-light setups. Move the main light and the reflector or fill light in and out, up and down, to vary contrast, shadow placement, and fill effects.

- Place the main light low on either side of the subject to reveal texture.

- Raise the main light high to minimize or eliminate unwanted shadows, especially if you must work close to a wall or other background.

- Aim a direct or diffused main light from the front and down onto a young, beautiful subject. Have him hold a reflector, so shadows under his chin, nose, and eyes are "filled." This "beauty" light reveals all, but is flattering.

- Make a habit of metering carefully with an in-camera or handheld meter (see the section on Exposure and Metering, beginning on page 40).

- With nonadjustable film cameras, "point and shoot" under lights as you normally do outdoors, but do not aim the lens directly at lights.

- With a digital camera under hotlights, meter and shoot as you normally do in daylight, but do not aim lens at lights.

- With any adjustable film camera, under hotlights, meter and set a moderate f-stop on the lens and the appropriate shutter speed for "normal" exposure.

- Use a flashmeter to meter the strobe. Be sure to set "synch" and film speed on the meter first, then on the camera. Then set the lens aperture.

- Soften the effect of any type of light by aiming it so that light bounces from a white reflector, wall, or ceiling, or a purpose-made white umbrella.

- "Bounce" (reflected) light is even, often flattering. Bounce effects vary, depending on size of the bounce surface, its angle, and its distance from the light and the subject.

- Remember when bouncing or diffusing light that both reduce light range.

- For more detail about all the above subjects, refer to the following sections: All about Hotlights, Exposure and Metering, Battery-Powered Flash, and Lighting with Strobes.

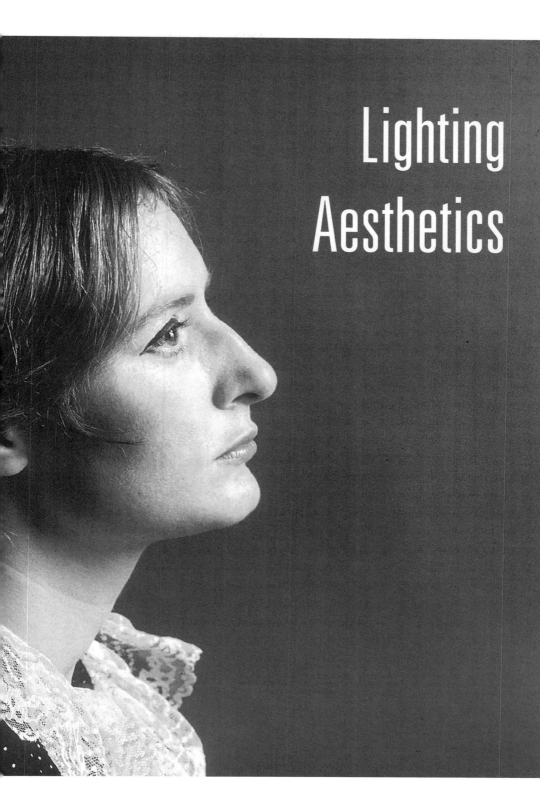

Lighting Aesthetics

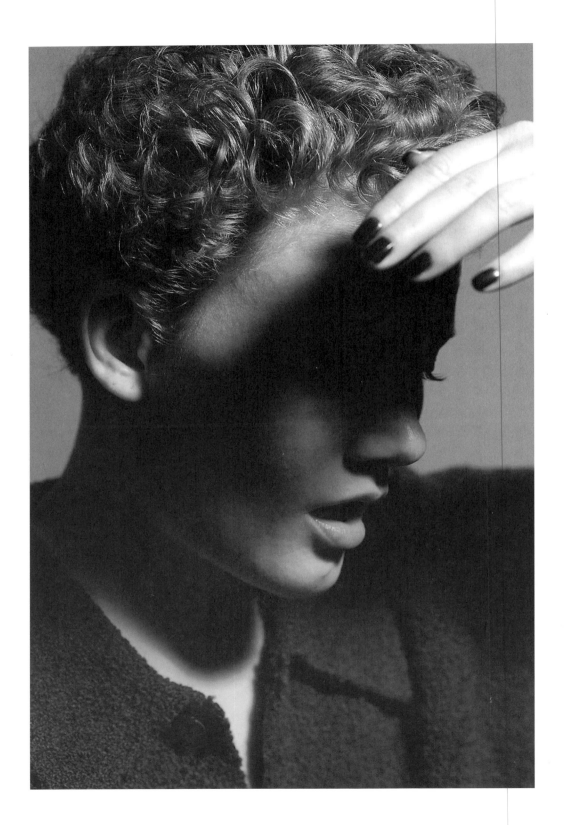

Achieving the Right Mood

Lighting photographs well means much more than shining enough light onto a subject for a good exposure. When you know what you're doing, lighting allows you to create the mood or "look" of your subject without having to wait for natural light to change or praying that the existing lights will result in effects you like.

Photo lights can be used to make a picture look soft and romantic or sparkly and fun—or exciting, dramatic, stark, drab, and more. Light can maximize detail, show texture, minimize defects in imperfect faces, and make mundane objects look terrific. With knowledge, patience, and a good "eye," with lights, you can achieve effects never to be found in nature or on the streets.

For inspiration, look at light wherever you go. Then imagine how you would recreate such effects in a studio.

To start lighting, use any uncluttered space as a studio. You should be able to darken it. In dim light, pose a willing human subject, or set up an object or still-life group—I sometimes use a mannequin. Take a light, and study the many effects you can create by moving it around, up or down, nearer to or fur-ther from your subject. (A flash won't do for this experiment, because a flash gives a burst of light so brief you can't easily see its effect.) You will be surprised at the variety of moods you can create so simply.

How Light Records on Film and Digital Media

Our naked eyes can see detail in the deepest shadows and brightest highlights, even both at the same time. But film, digital media, and paper are not so nearly so versatile. They cannot reproduce extremes of contrast.

An important part of learning lighting is to be able to meter accurately. Lighting in a scene should be within the range of tones that will reproduce as black-and-white slides or prints, color slides, or color prints. Digital images destined for display on the Web or to be printed cannot be too contrasty, either.

In general, aim for fairly even lighting, with not more than about one-and-a-half f-stops' exposure difference between large, bright areas and large, dark areas in any composition. Small, darker shadows or brighter highlight areas are okay. You will soon learn what "works"—or doesn't—for you.

Lighting and Contrast

With all lighting, but especially for color slide film and for digital imaging, it is best to aim for moderate contrast in the composition. As mentioned earlier, the difference between the lightest and darkest areas of an image should not be too great—with film, about a one- or one-and-a-half f-stops' difference between the darkest and lightest areas is good. For digital, avoid high contrast—about one-half to one f-stop's difference is safest.

Avoid creating big "black holes" or blasted-out white highlight areas in your compositions, or even—*horrors!*—both in the same picture, which is possible with too-high-contrast lighting. Filling in shadow areas with a reflector or with a second light is often a necessity to reduce contrast.

In the Lighting Overviews section of this book, I wrote that many variables can affect the "look" of photo lighting (pages 8–9). It's not always easy to figure out how a picture you admire was lit, so experiment with light modifiers.

You will become aware as you work with lights that some types of light are better suited to certain subjects than others. No one type of light does everything well, everywhere.

Remember, though, that lighting suggestions made here are not written in stone. Shoot using your lights the way I suggest, then experiment. Shoot, view, and then decide what works well for you.

Light Aimed Direct and Light Used "Bare Bulb"

A light of any kind aimed direct with a polished reflector behind it casts a hard shadow; the size and finish of that reflector affects the "look" of the light quite a lot. Most reflectors are between about four and ten inches across, but huge, twenty-four-inch or even bigger white reflectors are currently popular with professional fashion and beauty photographers, who often use them behind strobe heads.

A "bare bulb," on the other hand, is any lamp or tube used without any reflector; it casts a distinct but pale shadow.

Diffusing and Bouncing Light

Translucent white "shoot-through" umbrellas diffuse and spread light considerably with flattering results. I often use thirty-six-inch umbrellas, which are inexpensive and easy to set up with any type of light. (You may need to buy an umbrella clamp.) Bigger, forty-two-inch or forty-eight-inch opaque white umbrellas are for bouncing light, with the effect of slightly harder shadows. Big silver umbrellas bounce light, too, with a more "sparkly" effect and pale, distinct shadows. I also have a tiny one I use with flash.

Forty-eight-inch and bigger professional "black-backed" white or silver umbrellas bounce light. Used up close, they reveal facial planes and give deep, soft shadows.

Devices That Concentrate or Narrow Light Spread

Devices that restrict light coverage to some degree, or that can narrow its spread to illuminate only a small area, or that cause it to fall off gradually, include barn doors, snoots, and grids.

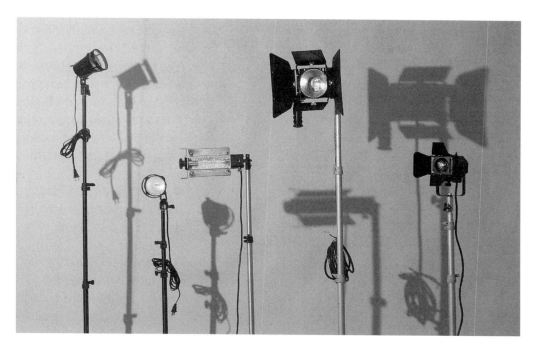

ABOVE: The light used to make this photo was a 500 watt photoflood lamp used "bare bulb" (without a reflector). Note the distinct but pale shadows.

BELOW: The small round Smith-Victor quartz lights at left, and the quartz Lowel Tota and Omni lights with barn doors, were lit with a 500 watt photoflood lamp in a 10-inch reflector. Note the deep shadows.

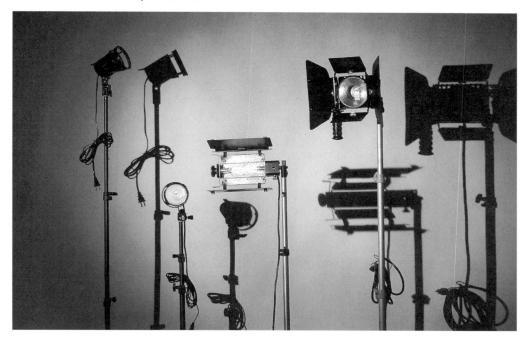

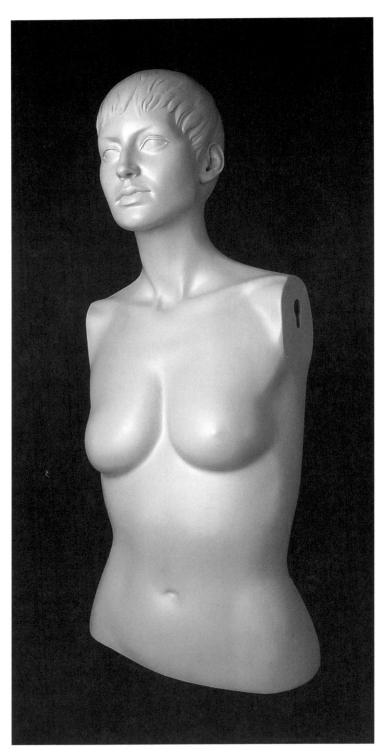

It's easier to show than to talk about how they alter light effects. Some are available to fit hotlight fixtures, and many are made for strobes, but they are not generally made for flash units. See page 85 for examples.

Use What You Have to Begin—Add Lights When and If Needed

I have already written that to begin lighting, you can get excellent results with just one adjustable photo light of almost any type, plus a white or silver reflector, a tripod, a white umbrella, and one or two adjustable light stands that extend to six feet or higher.

If you don't have the equipment I suggest, don't panic. Try getting effects you like and doing the suggested self-assignments (later in this book) with any lights you own—at first, anyway. If you find your equipment truly limits you, then, of course, think about adding to it.

This shot could be made with a hotlight, flash, or strobe if bounced out of an umbrella onto the subject. Of course, exposure and light distance from subject would be different in each case.

Lighting and Color Balance

Besides the quality of light, there is one other aesthetic to be considered when first lighting photographs—that is the color of the light as it reproduces on film or digital images. Films and pixels do not record color exactly as our eyes see it.

"Color balance" just means that the colors you see with the naked eye reproduce as accurately as possible on slide films, on prints of all kinds, and in digital form. (Color balance will probably never be perfect, but excellent is an achievable goal.)

Of course, there are no problems with getting good tones under any type of light source if you are shooting black-and-white film or digital images.

Color Balance and Amateur Color Negative/Print Films

Color balance with amateur color negative films destined for prints is not too critical; these films can be used in daylight or under hotlights—any overall color cast is corrected quite well by minilabs during printing.

I like Kodak Gold and Fuji Superia color print films. Both come in ISO 100 and ISO 400 speeds for use in bright or low light. A good amateur color slide film is Ektachrome Elite from Kodak. Use with flash or strobe for accurate color.

Light Balance and Professional Color Films

With professional color films, especially color slide or transparency films, it is important to "balance" (match) the film type to the light source being used for accurate color.

The color of light is measured by the Kelvin scale, in degrees Kelvin (written as a number plus K, or °K—for more, see page 28).

All daylight-type films are balanced for 5,500°K. Daylight films are used for daylight, flash, and strobe exposures. I personally don't use daylight negative/print films much, because I don't normally shoot for prints (I use slide film), but I do like Kodak Extapress if prints are called for. I use Fuji Provia, Astia, and Velvia, and Kodak Ektachrome—all professional daylight-balanced slide films—under flash and strobe lights. All have slightly different qualities—experiment to find your favorites.

Type S (for short exposure) professional color negative/print films are also color-balanced at 5,500°K and used with daylight, flash, and strobe lights. Kodak Portra is excellent; it comes in NC (normal color) and VC (more saturated, slightly warmer tones).

Professional Color Films for Tungsten Lights

Tungsten flood and quartz lamps made today are almost all balanced to give correct color with color slide films balanced for 3,200°K. Ektachrome 320 tungsten film is my favorite. Scotch/3M 640 (ISO speed) tungsten film gives interesting, grainy effects. (If you use daylight color slide films under tungsten lights, the result is an overall orange cast.)

Professional Type L (for long exposure) color negative/print films are designed to give excellent color, especially of skin tones, under 3,200°K hot-

lights. Kodak Pro 400 MC is recommended by a colleague.

Color Correcting and Light Balancing with Filters and Gels

CC (Color Correcting) and LB (Light Balancing) filters and "gels" (precisely dyed thin plastic sheets) come in varying percentages of blue, orange, magenta, and cyan (blue-green). They may be needed over lenses or in front of lights to achieve almost perfect color rendition with professional films. (They are used in enlargers, too, for making fine-art color prints.)

However, in this digital age, precise color filtration is not quite so crucial as it once was. Film images are now routinely "scanned" (digitized) and the resulting file transferred to computer. Color correction and minor retouching of good digital originals and scanned, digitized images are now fairly easy, even for moderately skilled users of photo enhancement software programs like Adobe Photoshop.

Color Balancing of Digital Images

When shooting digitally, first set the "White Balance" mode on your camera to match the light source as closely as possible. Options are often Auto, Sunlight, Cloudy, and Tungsten, and sometimes include Fluorescent and Custom options (see your camera manual).

Digital images from any camera can later be "downloaded" (transferred) to a computer. Then, the brightness, contrast, overall color cast, and much more can be fine-tuned or "tweaked" via photo modifying software. The photo industry standard is again Adobe's Photoshop program. It comes in full and "Lite" versions.

The Kelvin Color Measurement Scale Summarized

Lord Kelvin, a British physicist, first measured the color of light in the nineteenth century. In a famous experiment, he heated a "black body"—probably an iron bar—in a furnace and observed changes. The iron first changed from black to glow a deep purple, then turned red, orange, and yellow as it got hotter. Eventually the lump of iron became white hot, and ultimately, when the furnace was as hot as it could get, the iron emitted a bluish gas.

Therefore, on the Kelvin scale, the redder or "warmer" the light, the *lower* the "color temperature." The bluer or "cooler" the light, the *higher* the Kelvin number.

The important Kelvin numbers to remember are 5,500°K and 3,200°K—the colors of daylight and today's hotlights. Films are color balanced for one or the other.

The (theoretical) color of noon daylight, on a sunny day with some clouds in the sky from spring to fall in the Northern Hemisphere, is fixed at 5,500°K. All daylight films and all strobes and flashes are balanced to give correct color at a Kelvin temperature of 5,500°K.

Tungsten photo lamps made today are almost all balanced to emit light at 3,200°K. All tungsten slide films (except Kodachrome Type A, a film now little used) are designed to balance with

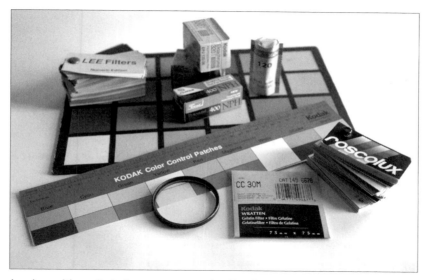

For good color with a digital camera, use the Daylight white balance setting with flash and strobe and the Tungsten setting with hotlights. (See camera manuals for more.) Color film must be balanced to the light source. My favorite Ektachrome 320T film shown here is balanced for 3,200°K photofloods and quartz lamps. Other major film manufactures offer tungsten films also. Filters are used in front of lenses and gels in front of lights to assure critical color. The Kodak and Gretag Macbeth color control patches shown can be included in the frame if desired, to assure critical color matching.

3,200°K tungsten lamps. Professional Type L color negative/print films are balanced for 3,200°K lights also. The lighting in most sports stadiums is balanced for 3,200°K as well.

As those theoretical color temperatures, and also color film emulsions (batches) and light sources, can vary slightly from the norm, CC (color correction) filters may be needed to achieve excellent color on professional films. (Refer to the discussion of filters and gels on page 28.)

Household lights emit light with a color temperature of about 2,900°K, oil lamp and candlelight about 2,000°K, and sunrises and sunsets about 1,900°K. The glow from a low fire may be as low as 1,000°K. All those things record as warm or extremely warm shades of yellow, orange, or red on daylight films or on digital images if the White Balance mode is set to daylight. (Sometimes you want a warm effect, of course.)

If the sun in a blue sky goes behind clouds, color temperature rises, gets bluer than 5,500°K. Light on a beach or in snow is quite bluish, too. Bad-weather overcast light is very blue, about 6,500°K to 7,500°K, and at twilight, the deep blue sky can go as high as 17,000°K. All those conditions give a bluish or bright blue overall colorcast to daylight film. Using color tungsten films, or tungsten digital settings, in daylight or under flash or strobe lights can result in a strong overall blue cast to your image. Correct this, if you wish, with filters or by other means—but remember that sometimes the "wrong" color can create just the mood you want. No rule is unbreakable!

Note that "color temperature meters" made by Minolta suggest CC or LB filters needed under mixed light sources, but do not meter exposure.

All about
Hotlights

An Introduction to Photoflood and Quartz Lights

I've already discussed tungsten, or hot-lights, in the first section and do so again here in some detail, because hot-lights of any type are unrivalled for learning lighting, and they have their own lighting aesthetic.

Most hotlights used by still photographers are lightweight, and floodlight tungsten fixtures and lamps are inexpensive. They are excellent for still lifes and for portraiture of inexperienced subjects, because they remain constant without surprising flashes that can cause subjects to blink a lot. Quartz-type hotlights do the same thing, with hotter and thus smaller lamps and fixtures. Most quartz lights are moderately priced, compact, and easy to pack and carry on location.

So-called HMI Daylight-Balanced hotlights, generally used by fashion photographers, are extremely expensive. I am not dealing with them in this book. For information about these lights, refer to the lighting dealers whose contact information is listed in appendix B, on page 158.

There are only four hotlights in this picture. The realistic hard shadows were created by one 250 watt focusing spotlight that I bought some years ago for $40 in a theatrical lighting store. The spot was placed about 6 feet to camera left, about 4 feet from the fixtures in front, at about 6 feet high. I angled the light carefully so the hotlights' highly polished reflectors were illuminated. I exposed by aiming my built-in camera meter at the light gray paper background. Basic reading was ¹⁄₁₂₅ at f/11. I shot normal as well as plus and minus ½ f-stop exposures.

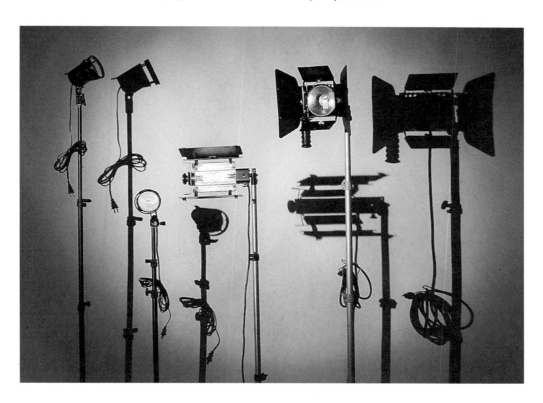

How Photoflood Lights Work

Tungsten photoflood lamps are the least expensive photo light you can buy. Used in a large metal reflector, they have a pleasant, inherently softer effect than flash or strobe. These lights consist of a tungsten metal filament sealed into a glass cover with a metal base. Photoflood lamps look and act like household bulbs, but are bigger. All photofloods are "balanced" to emit light at a certain "color temperature," or "Kelvin temperature," to render accurate color with specific professional color films (see page 28).

Photofloods are screwed into fixture sockets. When the fixture is plugged into an AC electric outlet and switched on, AC electric current reaches and heats the metal filament of the photoflood lamp, so that it emits a continuous source of bright light at a regulated color temperature.

Purpose-made fixtures with reflectors for photoflood lights retail for between about $35 and $75 each, and they can be bought in kits with light stands. I like and use the Smith-Victor Smith kit (see page 35).

Note: The big professional fixtures used to light TV and movie sets are outside the province of this book, but see the resources section at the end of this book to contact manufacturers if you want to learn more about those.

Smith-Victor Hotlights

I like and use Smith-Victor hotlights, both for teaching lighting and for portraiture.

Buy these lights individually or as a kit. A 500 watt "Thrifty" tungsten floodlight kit consists of two photoflood fixtures with ten-inch reflectors, two six-foot light stands, and two 250 watt ECA photoflood lamps in a corrugated carry case. It can be bought for about $110–125. A 1,000 watt kit costs only about $30 more. For maximum safety, I would add two ceramic socket protectors to either, for about $3 each at hardware stores. You will also need to buy grounded extension cords.

Smith-Victor also markets a handy, fist-size 700-SG quartz light fixture. It takes peanut-size bulbs and has a heat-resistant glass cover. It retails for around $75, and two fit into a camera bag. Along with stands and a big silver umbrella, I have used these fixtures for many commercial portrait jobs.

Quartz lamps contain halogen gas. This causes the tungsten lamp filament to burn extremely brightly. The photoflood lamp and the quartz lamp here are both rated at 500 watts. This obviously shows that quartz fixtures are extremely compact compared to equivalent photoflood lights.

How Quartz Hotlights Work

"Quartz" lights, or more correctly, "quartz-halogen tungsten lights," are perhaps the most versatile type of hotlight. They can be extremely useful to still photographers (but not for stopping fast action—for that, you must use a flash or strobe). Quartz lamps are tiny—from about the size of an unshelled peanut to about the size of a cigar—and their fixtures are, in most cases, convenient to carry. They are moderately- to medium-priced, with optional light-modifying accessories available. To me, they are excellent as teaching and learning tools and are highly practical for much professional location lighting. For years, I carried a couple of small quartz fixtures in my bag whenever I photographed people indoors but was away from my studio. Along with the quartz fixtures, I carried a tripod, two light stands, clamps, and a big silver umbrella.

Quartz lamps utilize halogen gas and a tungsten filament sealed into shock-resistant quartz glass envelopes. The vapor causes the tungsten filament to burn hotter and brighter than photoflood lamps of equivalent wattage. As with photofloods, photographic quartz lamps are designed to emit light at a specific color or Kelvin temperature—3,200°K—to give accurate color with professional Type L color negative films and tungsten-balanced professional color slide films. Different quartz lamps come in 250, 500, 600 and 1,000 watt versions. They attach to quartz fixtures with pins.

The differences between photoflood and quartz lights of equal wattage have to do with size, weight, and price: 500 watt photofloods and 500 watt quartz lamps give out the same amount of light, but because the quartz lamp is tiny, quartz fixtures are smaller and easy to pack and carry. Photoflood lamps cost under $5 each, while quartz lamps start at around $25.

I have already mentioned Smith-Victor's handy-size 700 SG quartz light. Marketed as a video light, it accepts 250

ProTech's adjustable umbrella mount. Use it with a Smith-Victor 700-SG quartz light or any detachable flash with a foot—or professional flashes equipped with tripod bushings. This accessory comes with a flash shoe and a universal lighting stud and costs around $20.

The most compact quartz fixture I know of is the 500 watt Smith-Victor 700-SG unit, shown here aimed into a white umbrella with the aid of ProTech's umbrella-mount device.

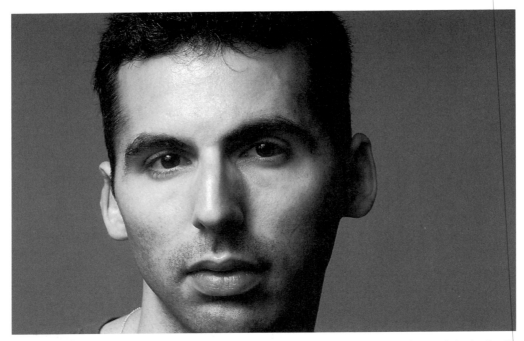

Lighting was one 500 watt Smith-Victor quartz light, aimed out of a forty-eight-inch sil-ver umbrella placed at the high three-quarter position at camera left. Because I wanted a dramatic effect with strong shadows, I did not use a reflector or a fill light. Exposure was by in-camera meter, at 1/60 at f/8 with an ISO 400 digital camera setting. I used a tri-pod and an 80mm lens.

or 600 watt peanut-size bulbs and has a glass heat shield, and optional "barn doors" for controlling shadows are available. Two fixtures easily fit into an average-size camera bag. I carried a pair for years to light portraits.

Lowel's Omni Light

This versatile professional quartz fixture takes cigar butt–sized bulbs, has a built-in adapter for inserting a white umbrella, a wire safety grid, and sturdy rubberized handle for easy angle adjustment. It can give a moderately concentrated "spot" effect or a moder-ately spread "flood" effect. The fixture folds to a compact size. Quite a few accessories are available. They include barn doors, a gel holder to hold light-

balancing or color-changing gels in front of the lens, as well as "snoots" and "grids" that concentrate light consider-ably. Running on 110 volt AC current for use in North and South America and Japan, with correct lamps, Omni fixtures can also be used in Europe, Australia, and other countries where 220–240 volt current is standard. I own three Omnis; they are great for travelers like me.

Lowel's Tota Light

This broad, professional light source folds up small for packing, has a protec-tive wire screen, and barn doors to con-trol shadows. It is generally used in multiples for lighting room sets or large areas. It takes cigar-size quartz lamps. I own three of these.

Working with Two Hotlights

Most often in two-light setups, one light is used as the "main" or "key" light that defines the subject, while the other is placed further away, or fitted with a lower-wattage lamp, and is used as the "fill" light to "open up" (lighten) shadows. (For directions for working with just one hotlight, refer back to pages 10–12.)

Alternatively, one light can be on the main subject, with the other aimed at the background. Then, you might still wish to lighten shadows on the subject by placing a portable reflector opposite the main light. (Shadows appear darker on film or digital media than they do to the naked eye.)

A third approach is to have a main light plus a light shone down from behind or to the side, onto a portrait subject's hair to give it shine and separate it from the background. This is called a "hair light."

This portrait was lit by two 500 watt Lowel Omni lights. The main light at left bounced out of a white umbrella was about four feet from the subject. The high key sidelight was aimed direct from slightly behind him. Barn doors controlled the spread of light. With an incident-light meter, the highlight was one stop brighter than the main light. I bracketed the exposures on ISO 100 film.

Exposure and Metering

Exposure Fundamentals

Today, most cameras have wonderfully accurate exposure meters built in, so average snappers simply "point and shoot" and take good exposure for granted. However, to use light creatively, you must get used to working with your camera in manual mode, or at least use Shutter Priority or Aperture Priority to give you greater control. In this book, I assume that you will set exposure on your film or digital camera manually.

To truly control lighting, though, you need to understand what exposure meters are intended to do, what they cannot do, and how to use them.

Wratten and Wainright, photo scientists who perfected reflected-light meters, first measured light intensity more than a hundred years ago. They determined that an *average* subject is a middle tone, 18 percent of true black. An average, mid-toned subject reflects back 12.5 percent of the light that falls on it.

A homemade board to record exposures. The patches were given to me by a lab and glued to a child's chalkboard. If the top row of black to white squares all record as separated, exposure is extremely accurate. The bottom squares represent standard printing ink colors. By including such a board in film or digital test shots, you can keep notes and get accurate professional or home-computer color reproduction—especially important if shooting skin, products, or artworks.

Reflected-Light Meters

Reflected-light meters of all types measure the light that reflects off the subject. *All meters built into cameras are reflected-light meters.* Handheld reflected-light meters are still made, although they are not used as frequently as they once were (handheld incident-light meters have begun to replace them). I assume you are using a camera with a built-in meter. However, if you are using an old camera, or a view camera, get a handheld meter, preferably an incident-light meter (more about that later).

Reflected-light meters of all types are designed to render subjects to reproduce on film (and today, onto digital media) as a middle tone. When aimed at the subject, they read the light that reflects back from the subject. If the subject is mid-toned, exposure will be excellent. Green grass, washed blue jeans, and gray roads, sidewalks, or rocks are all more or less middle gray, and if you meter off these or any mid-toned subject, your picture will reproduce detail in light, mid-toned, and dark areas.

The problem for inexperienced users of reflected-light meters is that a darker-than-mid-toned subject or a white or bright subject will cause exposure errors. The meter will give readings and indicate exposure settings that will cause blacks to overexpose and whites to underexpose, and both to reproduce as grayish tones, close to 18 percent gray.

If you aim a reflected-light meter carefully and meter off a middle tone, the whole subject or scene should reproduce correctly, with viewable and printable detail in light-, mid-, and dark-toned areas of a composition (provided highlight and shadow areas are not too contrasty—see page 43).

Outdoors, green grass, medium-blue jeans, gray rocks, and gray sidewalks are all close to middle-tone. Aim a camera's built-in reflected light meter, or any handheld reflected-type meter, at any of those mid-toned subjects *in the same light as your main subject*, and you will get a good exposure. In the studio, aim your reflected-light meter at a gray card to avoid its being influenced by subject tone. For built-in metering options, refer to your camera manual.

If you meter off, say, white snow or any bright light indoors or outdoors at night, the meter will indicate an exposure that will reproduce these bright things as an average tone. The result will be dark, dingy snow or pinpoints of light in a dark picture. Overexposing by one-and-a-half or two f-stops will reproduce the scene as white.

If you aim any reflected-light meter at anything black, a proverbial black cat in a coalhole will reproduce as a gray cat in a gray hole. Meter off the gray card (see page 43) to reproduce the scene accurately. Or meter off coal and *decrease* exposure by one-and-a-half, then two f-stops, for correct reproduction of the scene. If your lens does not have click stops halfway between the major f-stop numbers, you will need to manually line up the dial line between the f-stop marks when increasing or decreasing exposure by one-and-a-half f-stops.

Metering Under Lights with a Built-In Camera Meter

Today, almost all user-adjustable cameras have a built-in light meter, which in all cases measure the light that reflects off the subject (see page 42). The meter in modern single-lens reflex cameras is directly behind the lens (hence "TTL" or "through-the-lens" metering) or somewhere very close to it.

Meter under lights the same way that you meter in daylight—by pointing the lens at the most important part of the composition. Do not point the lens at the lights themselves or include them in the picture "frame" when metering, or you will get dark, underexposed prints or slides.

If a subject is contrasty, especially a composition with bright highlights and dark areas, work close, and meter the most important element in your picture—a face is an obvious example—to get the most accurate exposure possible.

The 18 Percent Gray Card

Kodak and other companies market 18 percent gray cards that fit into a camera bag. Gray cards reflect back 12.5 percent of the light that falls on them. If you carefully aim any in-camera or hand-held reflected-light meter at such a gray card when metering, the resulting exposure reading will not be influenced by the tone of the subject. This is especially valuable when metering very light or very dark subjects.

If you include a gray card in a test photograph and then compare a slide or print with the original card, you will immediately see if exposure is too dark or too light.

The gray page reproduced on page 44 is very close in tone to a standard gray card—use it as a gray-card substitute. Have a model under lights hold the book (or gray card), and meter off it. If the gray reproduces correctly in your slide or print, you have a good exposure.

A reflected-light meter, whether built in to a camera or a hand-held model, is always aimed at the subject. It is influenced by the tone of that subject and is designed to reproduce that subject—whether light, mid-toned, or dark—as a middle tone. To avoid this, meter off a mid-tone in any outdoor scene and manually set exposure accordingly, or use the "memory lock" option on your camera, if available (see your manual). In a studio, move close, and meter off a mid-tone or off an 18 percent gray card, as shown here. (A gray-card equivalent is printed on page 44.)

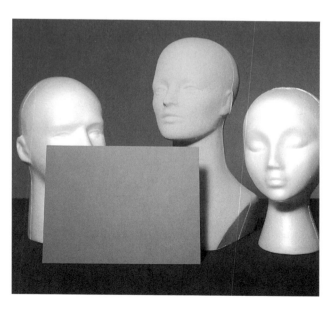

An 18 percent gray card (approximate). Include this page, with the white page as a bor-
der around the gray card, in a frame. If all the gray and black tones and the white border
look correct in your digital or film image, you have good exposure.

Exposure Latitude

Latitude, in photography, means tolerance for variation from an ideal exposure that records detail in all tones, from light to dark, in a subject. Latitude can vary according to the film or medium. With lighting, it's not only overall exposure you need to worry about—it's the relative brightness of one light to another.

Exposure "latitude" with all negative films is good. These films have a fair tolerance for "high contrast" in lighting, or a wide tonal range between the brightest and darkest areas of a composition. *In general, if you shoot negative film for black-and-white or color prints, it's safe to expose for shadow detail.* By exposing for shadows, you or a lab can make good prints showing shadow detail, and (if necessary with high-contrast subjects or compositions) still be able to "burn in" overexposed white or highlight areas.

Color slides, and the rather new black-and-white transparency film Agfa Scala, have little exposure latitude. Overexposure will cause highlights to burn out and be lost. *So, with chromes of any kind, expose for highlights, and let small, deep shadow areas go black if necessary.* I "bracket" (vary) color slide exposures by one-third or one-half of an f-stop over and under "normal" exposure whenever possible (see page 46 for examples).

Digital Exposure Latitude

Digital media always needs to be exposed for highlights. If digital images are overexposed, detail is lost and can't be brought back even with extensive manipulation in Adobe Photoshop. I learned not to overexpose when first using a digital camera to make "white on white" pictures for this book. The first ones were awful, completely "blown out" and unprintable.

I sought advice, then went back and underexposed the white images slightly. Then I was easily able to render extremely subtle differences in white tones by adjusting "curves" in the Photoshop program.

Digital images are tolerant of underexposure. It is easy to lighten even shots that are considerably underexposed using Photoshop.

Bracketing Film Exposures

If you "bracket" (intentionally vary your exposures), you will take care of many exposure latitude problems, and can vary a picture's mood, too. I use one-half f-stop under and over normal as brackets. Some people, using modern cameras, can bracket with one-third f-stop increments. Bracketing can be done manually by altering either the f-stop or the shutter speed—or, if you are using an advanced electronic camera, you can select its built-in bracketing option. Refer to your camera manual to see if this option is included. I don't tend to bracket digital exposures much, unless the scene is extremely contrasted, because digital exposures can easily be adjusted later in Photoshop.

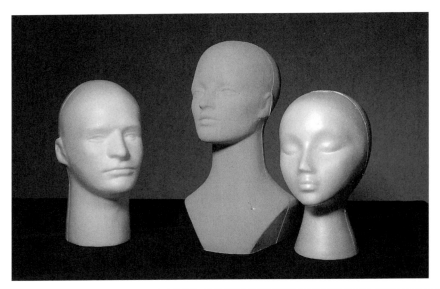

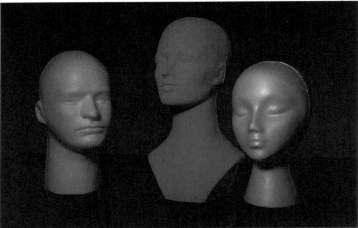

Bracketing, or varying exposures, ensures you will get the exact "look" you want—what the exposure meter suggests may not always convey this. The first picture is "normal" as read by the camera meter; the second is one-half stop underexposed; the third is one-half stop over normal. You choose the effect you prefer.

How I Expose Under Hotlights

I totally rely on my TTL, in-camera meters for exposure readings when shooting under hotlights. I almost always use the camera's "matrix" (or similar name) or wide-area metering mode, because it works fine. If lighting is somewhat contrasty, I move close and meter the most important area of my composition—the face in a portrait, for instance.

I learned photography with manual cameras, so by sheer habit, I adjust shutter speeds and lens apertures, with my electronic cameras set to M (Manual mode). You may prefer S (Shutter Priority mode) to choose shutter speed when that is critical, or A (Aperture Priority mode) to adjust lens aperture when you want to control "depth of field" (the zone of sharp focus). With either the S or A modes, the camera program adjusts the opposite setting for correct exposure.

Don't normally rely on P (Program) exposures, or you will essentially be "pointing-and-shooting," even with the most sophisticated cameras. But if the light is contrasty and changing very rapidly, program mode can adjust exposure fast—I use it, with the camera meter set to "spot" (narrow angle) mode, if shooting at the circus, for instance.

Exposing Under Hotlights with Program-Only Cameras

If your entry-level film or digital electronic camera only permits shooting with A (Auto) or P (Program) modes, first, turn off or tape over the built-in flash. Always move in close to meter the most important area of your subject.

Metering and Adjusting Hotlight Exposures with a Digital Camera

With any digital camera, meter hotlight exposures with the in-camera reflected-light meter. Just aim the lens at the most important part of the subject, moving close to determine exposure. Play back and view images to check exposure if you wish.

Correct contrast problems and adjust shadow placement by moving your main or "key" light. Move the light up or down to alter shadow position, close it in to your subject for more light, or pull it further out for less light. Vary "fill" effects on the shadowed side of the picture by moving the reflector in or out.

Do be aware that each time you play back a digital image in the camera, it may degrade the final result, so shoot a few tests to perfect exposure settings and light placements before making important shots.

Incident-Light Meters

Incident-type exposure meters were originally invented to aid in controlling exposure and contrast on movie sets, where many big lights were used at the same time. Now universally used in professional photo studios, they measure the light that falls on a subject, and they are not influenced by subject tone. All are handheld meters, and they can be identified by white domes that rotate on the front of the meter. Normally held level to the subject's position and aimed at the camera, they can meter flash, strobe, tungsten, and daylight exposures, alone or in combination. Most come with a flat disc that is used instead of the white dome to meter light aimed at flat subjects, like art or documents, and many have optional reflected-light adapters, too.

Incident-light meters are the most popular flashmeter type. Sekonic offers a versatile meter that measures flash and can also be set as a reflected-light spotmeter. It measures a narrow angle of reflected light, which is useful for those who shoot concerts, theater, or sports from a distance.

Advanced Metering

Incident-light meters can be used to measure the relative brightness of one light to another, allowing the photographer to finely adjust lighting contrast. It's done the opposite way to normal incident metering. The meter dome is aimed from the camera directly at each light, in turn. Then, it's easy to see if one light is much too bright or if there is a dark area that needs additional light. Adjust "light ratios" by turning power up or down, or by moving light nearer or further away.

Metering a Large Room or Setup

If metering a large scene, or a room lit with two or more lights, it is a good idea to take incident meter readings from several different areas to ensure that the overall light is even or relatively even, as preferred. Aim an incident meter from subject to camera as usual, and then

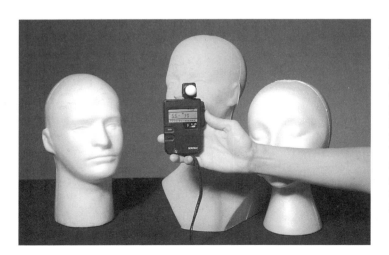

Incident-light meters are always held at the subject position and aimed at the camera position. Thus they are not influenced by the tone of the subject. Today's incident-light meters can measure strobe, flash, hotlights, mixed and existing lighting, and daylight.

This Minolta IV is one of many excellent flashmeters made by Minolta, a brand I favor. Here, it's used in Cord mode, physically attached to a strobe with a synch/pc cord. The photographer sets the ISO speed and shutter speed desired. When the meter is used, it instantly fires the strobe or flash, measures the brief flash, and then indicates the needed f-stop. The shutter speed and thus required f-stop can be adjusted at will without taking another reading. The meter can also be set to read daylight, hotlight, and existing light exposures.

move hotlights in or out to increase or reduce light intensity if needed. Varying settings on the unit can control strobe and flash output.

Establishing "Light Ratios"

A couple of paragraphs earlier, I mentioned "light ratios." You may have wondered what, exactly, this term means. Light ratios are a measurement of the difference between the lightest and darkest parts of a composition, expressed in numerical terms. A 1:1 light ratio means that two lights are placed so as to illuminate a subject totally evenly —usually to be avoided.

A 2:1 light ratio means the bright area receives twice as much light, or one f-stop more light, than the dark area, and so on.

Adjusting light ratios numerically is important only if you need to have absolute control of the range of contrast in large, complex lighting setups. The technique is mostly used for lighting big movie sets.

Don't worry much about light ratios when just beginning lighting. From my experience I find that exceeding about a two-f-stop difference in exposure in important parts of the same picture is usually to be avoided. Small brighter or darker accents can be okay.

Two excellent Sekonic incident-light meters. Both measure all types of lighting and have reflectance adapters. The L-608 model at left incorporates a reflected-light spotmeter, extremely useful to sports, nature, theatrical, and other event photographers who often use long lenses to photograph distant subjects.

Battery-Powered Flash

Overview

Portable flashes are powered by batteries or battery packs. (A few have optional AC power adapters.) There are three basic types of flash:

- **TTL (through-the-lens metering) flashes** are used with compatible TTL cameras. A sensor behind the camera lens and a computer within the flash control both overall exposure and flash output.
- **Automatic flash** output is controlled by a thyristorized sensor on the flash. A thyristor is an electronic switch that cuts off the flash power when sufficient light has reflected back to the sensor for a good exposure.
- **Manual flashes** put out the same amount of light each time fired (if fully charged and completely recycled). The easiest way to set a manual flash is by using a flash meter. Alter-

natively, you can use the Guide Number system to determine exposure (see page 71).

All flashes emit a very brief burst of light (about ⅟₃₅₀ of a second or shorter) that "freezes" or "stops" most motion.

There aren't many controls with the tiny flashes built in to consumer and midrange electronic film and digital cameras. I don't have much luck with the "Redeye Reduction" flash setting. This preflash operation intended to minimize the effect of light reflecting off the retina usually causes people to blink at just the wrong moment. I work as closely as possible to people to reduce the possibilities of "redeye."

Use "Flash On" mode to force a built-in flash to fire in daylight, thereby lightening shadows on sunlit faces or brightening them in poor weather. In

Cigarette pack–size detachable manual flashes cost under $20 and have an exposure guide scale on the back. This London subway shot was exposed at ⅟₆₀ at f/5.6 on color slide film rated at ISO 40, transposed to black-and-white for this book.

To use fill flash against the window, I angled the camera so that the flash would not hit the window, metered for the outside, and added fill flash with my digital camera in Program mode and my flash in TTL mode. While the result is quite good, essentially I was pointing and shooting.

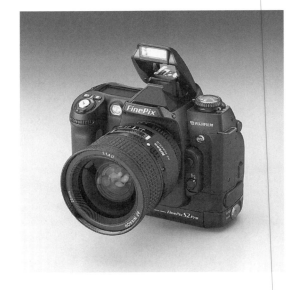

The new Fuji S-2 digital camera, one of the several well-priced 6 megapixel professional cameras with interchangeable lens, just arrived on the market as I finished this book. (The Nikon D-100 and the Canon D-60 cameras are direct competitors—see page 6. All have pop-up flashes that may be useful for informal shots, but detachable flashes can be attached and will give you more control.

I met these two New York heroes near Ground Zero, coming off their recovery shift at 4:00 one afternoon in April 2002. I posed them near Saint Paul's church, two blocks from the World Trade Center site. My digital camera, with a 20mm lens, was set to ISO 400 and gave an exposure of $\frac{1}{125}$ at f/11. I activated the camera's built-in pop-up flash to lighten heavy shadows cast by the men's helmets.

bright sunlight, a camera with a high flash "synch" (synchronization) speed is an advantage. On a bright, sunny day with ISO 100 film, a typical exposure is $\frac{1}{250}$ at f/11. At f/11 a typical 120 GN adjustable flash can fill shadows up to about 12–15 feet away. But if your camera "synchs" at the speed of $\frac{1}{60}$, you must shoot at f/22 in bright sunlight and can fill shadows only to about 6–8 feet away. Refer to pages 66–67 for more on flash synch.

Use "Flash Off" mode when a subject is obviously out of flash range. Set the camera on a tripod to shoot time exposures of landscapes and big interiors.

I avoid using Auto and Program flash modes. They fire a flash even when the main subject is hopelessly out of flash range.

How Flash Works

When a signal from a camera fires any flash (or strobe), it causes stored high-voltage electricity to pass through a sealed "tube" filled with xenon gas. This "excites" the gas, causing it to emit a brief burst of white light that is virtually the same neutral "color temperature" as noon daylight. Flash (and strobe) light can thus be unobtrusively blended with daylight.

Flash Guide Numbers

Flash power is always rated by the manufacturer's "Guide Number," or GN. The number is based on the use of ISO 100 film (or 100-speed digital setting), in feet (or meters, in countries where the metric system is used). The GN can be used to determine flash exposure. Most adjustable Canon, Nikon, Minolta, and other name-brand computerized TTL flashes and most adjustable automatic types of flashes have a GN of between 80 and 120 (in feet). For more information on using a manual flash's GN to determine distance and f-stop, see page 71.

The Inverse Square Law, or Law of Light Falloff

A famous law of physics states that the light from any single-point light source falls off *according to the square of the distance from the subject.* In photography, this means that all lights—including flashes, hotlights, and strobes—have a strictly limited range. To light large spaces, two or more lights carefully spaced out must always be used.

Note an exception to the Inverse Square Law: "Fresnel" lenses that bend light waves extend lighthouse lantern and spotlight range. (The lenses are named after their French inventor.) The only time you might want to use a flash at a great distance would be to shoot wildlife. Nature photographers George Lepp and Leonard Lee Rue both market Fresnel devices that, placed in front of flashes, approximately double their range.

Built-In, or Pop-Up, Flashes

These little flashes are handy, because they are with you whenever you carry a camera. They are fun for people pictures and parties, but not so suitable for photographing objects, room settings, and the like.

A problem with pop-up flashes is that it's all too easy to make pictures wherein

Flash falloff is illustrated here, using a 35–80mm lens and a 120 GN on-camera TTL flash aimed direct with an ISO 400 digital setting. With the camera set at 1/60 at f/4.5, I spaced three friends out on a twilit beach. I was about ten feet from Rick in front. He was about ten feet in front of Andrea, and she was ten feet in front of Chris. If you look at the faces or the sand, approximately of the same tones, and ignore the clothes that reflect different amounts of light, you will clearly see how the light declines and that the edge of the lit area is soft. If I had manually set the flash to expose Andrea correctly, Rick would have been overexposed, and Chris would still have been underexposed. If Chris had been correctly exposed, both Rich and Andrea would have been overexposed.

Flash fill was added to this scene at London's Waterloo Station. Exposure on ISO 100 film was 1/30 at f/5.6, with a 20mm lens. You can clearly see the light falloff, but the effect here seems quite natural.

ABOVE AND LEFT: Redeye (it looks like grayeye in black-and-white pictures) shows up when an on-camera flash reflects off the back of the retina of the eye. To avoid this, raise a detachable flash high above the camera on a bracket, or bounce an adjustable flash off a white card or LumiQuest device.

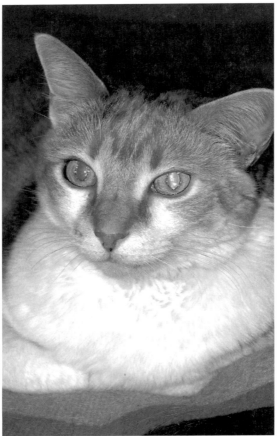

the subjects have red eyes. It is my experience that the Redeye Reduction camera mode does not help this problem much. Raising a detachable flash on a bracket is the best way to minimize redeye problems.

Detachable, Adjustable Flashes

Detachable flashes have more versatility than built-ins. Most are compact and lightweight and moderately- to medium-priced. A few inexpensive models point for-

A Nikon N-90 and SB-26 TTL flash were used to record this parade in Washington, D.C. Using ISO 50 film and camera Shutter Priority (S) mode, I set the shutter at maximum synch speed—1/250—and the flash to TTL mode. I metered off the brightest part of the scene, holding exposure and focus by keeping the shutter depressed halfway down. The camera program chose the f-stop, and the flash nicely filled in nearby shadow areas.

ward only. More expensive flashes can be angled upwards, and rotated as well, so harsh direct-flash effects can easily be modified. Take a lightweight adjustable flash anywhere and use it indoors or out, day or night, in bright sunlight or at night.

Mount a detachable flash on the camera's hot-shoe, or raise it on a bracket. An off-camera TTL flash must be connected to the camera by an appropriate TTL cord that connects flash and camera computers. Automatic flashes used off-camera will need a cord plus a sensor. Remote manual flashes can be connected to a camera by a synch/pc cord or by other means. By setting one or more flashes on light

stands, you can even mimic studio lighting.

Electronic camera computers can't "read" non-TTL flashes or strobes. For these, you must manually set the camera shutter to synch speed, or any desired speed below synch, on all cameras, and use a flash meter to measure exposure. (See Flash Essentials on page 75 for examples.)

Note: If using an older flash or strobe on any electronic camera, a Wein "Safe Synch" device is a good investment. It has both a flash shoe and a synch/pc cord outlet. Use it between camera and flash to protect delicate electronic camera circuits whenever shooting with non-TTL flashes, or with strobes.

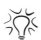

Quick Ways to Improve Flash Pictures

Here are two ways of using an off-camera flash aimed into a LumiQuest bounce device. This favorite of news photographers almost eliminates the risk of redeye in group shots and markedly softens flash effects—at the loss of two f-stops, or a 75 percent reduction in maximum flash range.

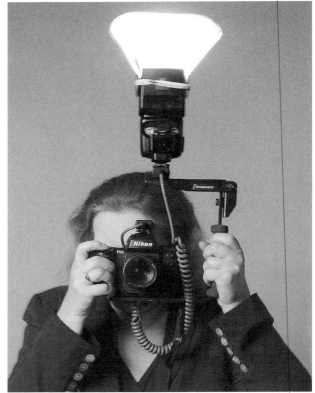

- Avoid "Auto" or "Program" flash modes on the camera. These will cause a built-in or detachable computerized TTL flash to fire in low light, even when the subject is out of flash range.

- With built-in flashes on program cameras, set "Flash On" mode in daylight to add "fill" light, for the purpose of brightening dark shadows on faces, people, or objects within flash range—the flash will not overpower daylight. ("Flash Off" mode forces the camera to set slow shutter speeds. Make shake-free time exposures of low-lit big spaces or landscapes by setting the camera on a tripod.)

- Shoot flash pictures close to people. A four-to-six-foot range usually gives pleasing effects. Make several flash exposures to get pictures without blinks. Often, it's best to shoot from slightly above or to one side of your subjects to minimize the chance of the dread "redeye" effect caused by the flash's reflecting through the pupil off the retina.

- Learn your flash's range (see camera manuals). Anything beyond flash range will be dark or will not record; anything too close will be overexposed. A five-to-ten-foot range is safe with a tiny flash or if using a slow lens.

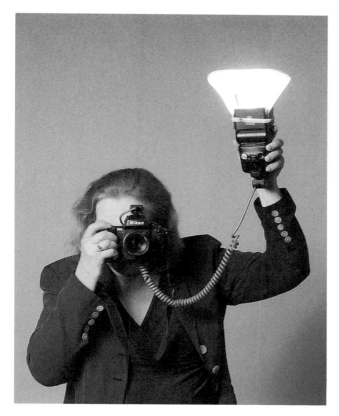

speed. Select this mode if a main subject is in shadow within flash range, and a well-lit night scene or interior is in the background, but out of flash range. Slow synch results set with a program or manually are unpredictable, but can be great. Use the camera on a tripod to minimize or control background blur and "ghost" images.

- Mount a compatible, adjustable TTL flash on the camera hot-shoe over any built-in pop-up type flash. This will reduce "redeye" problems, give greater flash range, and allow you to soften the flash with "light modifiers." (Most basic point-and-shoot cameras don't have a hot-shoe.)

- "Slow Synch" (or similar name) flash mode combines flash with a slow enough shutter speed to "burn in" backgrounds that wouldn't record with flash set to normal synch

- Tape a 3 × 5 inch white index card angled over an adjustable flash to soften light, or use an inexpensive LumiQuest or StoFen device (about $20) over an angled adjustable flash head to diffuse light and soften shadows (see photos).

- Mounting a detachable flash on a bracket or putting a light softener over a flash head almost eliminates the possibility of redeye. A drawback: Light modifiers reduce maximum flash range by about two-thirds.

- If using a light modifier on your flash, work within ten feet of the subject.

Flash Accessories

Flash used direct is a hard light. Flash effects can be softened with white cards or diffusing devices. Flash can be aimed through small soft boxes or bounced off white umbrellas. However, remember that all such devices reduce the amount of flash reaching the subject and require that you work very close to your subject when using them.

Most of the accessories can be used with any brand of camera or flash. From top left are Nikon's SB-26 flash fitted with a Sto-Fen dome. The combination is mounted on a Stroboframe Quick Flip bracket. The gray snake is Nikon's remote cord for TTL flash use off-camera. The black Quantum module fits in the flash battery chamber and connects the flash to a rechargeable battery pack. The on-camera flash is angled with its built-in white bounce card pulled up. The small flash on the right cannot be angled, but it is TTL-controlled and handy. It sits on Ikelite's Lite-Link, an excellent slave device that mimics a remote Nikon or Canon TTL flash. The three tiny Morris Mini Slave Wide Plus units are handy as accent lights. Wein's Safe-Sync device fits on a camera hot-shoe, permits use of any flash or strobe, and eliminates risk of damage to the delicate circuitry of expensive electronic cameras. Also shown is one of the many Wein slave units I own and a neat Underdog battery pack that attaches under my camera bodies.

If you shoot flash occasionally, a set of NIMH (nickel metal hydride) rechargeable batteries, available at Radio Shack and camera stores, is useful. If you shoot a lot of flash pictures, use a battery pack, made by Quantum and others.

Batteries

A set of disposable AA batteries in a flash recycles in five seconds or so for only about thirty-six exposures. It then becomes a maddening wait of ten or more seconds before the flash recycles.

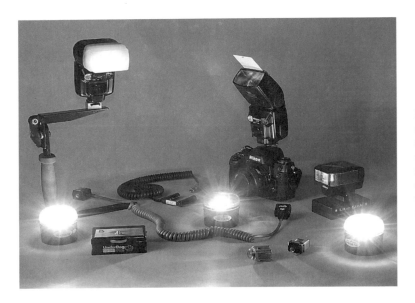

My Nikon flashes and favorite accessories. (Note that other major camera makers offer similar TTL flashes; there are good independent brands, too.

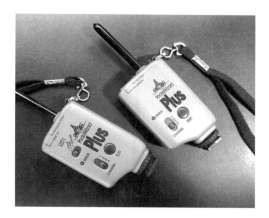

LEFT: A radio-controlled Pocket Wizard radio transmitter (or trigger) and receiver (or slave set). The cigarette pack–size trigger unit will set off slaved remote cameras or flashes and strobe lights up to 1,600 feet away. Additional receivers are optional. The pair shown here has four channels. Sixteen-channel Pocket Wizards are available also.

RIGHT: I had no tripod when I made this Slow Synch shot of a bartender in an upscale English pub. By resting my elbows on a chair back, I was able to get one sharp picture out of three at 1/8 and f/4 on ISO 50 film. I softened the light with a LumiQuest bounce device.

Battery energy is drained just by turning a flash on—the flash's storage capacitors have to be "formed" before the flash will fire. Also, batteries tire quickly when flash is fired rapidly, and they lose efficiency in the cold. Carry spare disposable batteries always. In addition, I rely on rechargeable, memoryless AA-size NIMH batteries and chargers.

Battery Packs

Battery packs are essential if you do much flash work, and you'll need different ones for digital camera work, too. I use various makers' rechargeable six-volt gel cell battery packs for cameras and flashes.

Quantum makes rechargeable lead-acid battery packs and battery-to-flash "modules" (connectors) for just about all flashes. Lumedyne batteries are excellent. Both brands are widely used and respected—I have a custom Lumedyne battery for my Fuji S-1 digital camera.

Jon Falk, a photographer and lighting guru from New Jersey, makes and markets "Underdogs"—small six-volt battery packs that attach neatly under cameras via the tripod bushing. I have relied on cigarette pack–size Underdogs for several years, and I highly recommend them. They come in pairs; two Underdogs give about three hundred full-power flashes and cost around $175 with a dual-voltage charger—great for

These are some indispensable Wein aides to flash and strobe photography. From lower left, clockwise: This inexpensive slave unit fits on a flash hot-shoe and has a synch cord outlet on the side, so that a camera without a synch outlet can be connected to a strobe with a synch cord. The SSR Infrared Transmitter, on a camera hot-shoe, will trigger a slaved remote flash or strobe without giving visible light. Wein's SafeSync device protects delicate camera circuitry from dangerous "spikes" or power surges from flashes or strobes. The inexpensive twin-bladed slave is made for studio strobes (models with European style prongs are available). The tiny Peanut slave clicks into a Vivitar flash's synch cord outlet, and it fits the tip of any strobe synch cord. Lastly, the Ultra Slave is sensitive to a considerable distance, even in bright sunlight—I have used it from as far as sixty feet away.

travelers like me. Battery-to-flash modules cost extra, and their price varies.

Flash Brackets

Raising a flash unit off-camera minimizes the chance of the flash burst's reflecting off retinas, a phenomenon that causes that unpleasant "redeye" effect. Lightweight Stroboframe Quick Flip brackets are the ones I use when photographing people and groups at events. Newton brackets are fine, too.

Remote Cords

Flash used off-camera must be connected to the camera in some way. TTL flashes require TTL cords. Automatic flashes require a cord with a thyristorized sensor attached. Manual flashes can be fired with a "synch" (flash synchronization) cord, sometimes called a "pc" cord, which physically joins cam-

era and flash. (A few TTL camera-flash combinations are radio-controlled.)

Triggers and Slaves

Many professional photographers use a "trigger" and "slave" combination to fire remote manual flashes (and strobes). The trigger is on the camera, the slave on the flash. Trigger/slave systems can be light-activated or radio- or sound-activated.

Secure "multichannel" infrared triggers and slaves offer up to four different settings, so casual flashes won't set off your flash. Radio systems offer up to fourteen channels.

Wein is a top maker of trigger/slave systems, with prices to fit all budgets. Quantum makes good systems, too. And finally, Pocket Wizard is top maker of radio-controlled trigger/slave systems.

See appendix B to contact manufacturers and learn more.

Detachable TTL Dedicated Flashes

Superb flash exposures can be achieved with user-adjustable computerized, so-called dedicated flashes designed for specific cameras. These are essential for news photographers and photojournalists, as well as for wedding and event specialists. If you are serious about making money by shooting parties and the like, you will be severely handicapped if you don't own a dedicated TTL camera/flash combination. (Remember, "TTL" refers to through-the-lens metering.) For my approaches to shooting parties and events, see Self-Assignment 8, beginning on page 113.

TTL flash exposure is controlled by a sensor placed behind the camera lens. (This applies to digital as well as film cameras.) The TTL/dedicated camera's meter takes both existing light and flash into account when computing flash exposures. Camera and flash programs interact to regulate flash output, shutting the flash off when there is sufficient light for a good exposure. Maximum flash range is limited and only achieved at the widest lens apertures. (See your camera manuals and this book's discussion of Flash Falloff, on page 56.)

TTL flash can be used with the camera set to Program, Aperture Priority, Shutter Priority, or Manual modes and also in Slow Synch (or similar name) mode. Top-brand TTL flashes can be set to either Automatic or Manual mode.

On top-caliber TTL flash models, flash output can be adjusted to suit your preference. A Select/Set button and plus-minus arrows permit you to choose more or less flash, in increments of one-half or one-third of an f-stop.

This is the back of the Nikon SB-26 TTL flash. It is a 120 GN flash, with a self-slaved option, and it can easily be found used. It works fine with my current Nikon F-100 and Fuji S-1 and S-2 digital cameras. The buttons permit you to customize the computer-controlled, through-the-lens metered flash output (refer to your manual). The most recent version of this flash is the Nikon SB-28. Note: Canon, Minolta, and other major camera brands offer TTL flashes with similar power and options. Visit your dealer for details of new models, prices, and so forth.

With some experience, extremely accurate and pleasing exposures are possible with dedicated flash, under varied light conditions.

Optional "dedicated cords" permit the use of dedicated flashes off-camera, with full TTL flash output control. The flash can be used on a flash bracket to eliminate "redeye" problems and to throw shadows down behind subjects.

Camera manufacturers market "TTL dedicated" flashes for electronic Canon,

Working in a cramped, dark room with a 20mm lens, I made this shot from quite close by aiming the TTL flash into a LumiQuest device. I wanted to burn in the low background lighting as much as possible, so I chose an exposure of ⅟₃₀ at f/5.6 on ISO 100 film.

Minolta, Nikon, and other top camera brands. Prices run from about $100 for a simple dedicated flash to about $350–500 for more powerful models with heads that can be angled.

Moderately priced Sunpak brand TTL flashes come with "modules" (adapters) for the above and other brands of electronic camera, and for some digital cameras, too. The price range is about $150–250.

Higher-end, professional Metz and Quantum brands offer TTL flashes with modules for Canon, Minolta, Nikon, and other brand-name film and digital cameras. These flashes cost from about $350–600. Battery packs are extra.

"Slow Synch" Flash Mode

When I acquired my first electronic camera and "dedicated" compatible TTL flash back in the 1980s, I wasn't always thrilled with results. Some of my program-set daylight flash pictures even looked like night pictures. That is because the electronic camera and flash programs set a shutter speed and lens aperture to both maximize flash range and minimize camera shake. This combination can, and quite often does, underexpose distant backgrounds out of flash range.

Improve flash images made in low light with the Slow Synch, Night Portrait, or Museum (or similar name) program

setting if shooting in big spaces indoors, or outdoors in brightly lit places.

Slow Synch mode combines slower-than-"normal" synch shutter speed with a TTL-controlled flash exposure. The flash illuminates dark foregrounds, and the long exposures "burn in" backgrounds and any existing lights present.

Even better is to use Shutter Priority (S) camera mode to select desired shutter speed, and let the camera set aperture and TTL flash output.

To control Slow Synch exposures manually, as most professionals do, set the shutter speed first, then use your in-camera meter to select a lens aperture that underexposes the background by about half an f-stop. Combine these settings with TTL flash, to light a bride and groom and show at least some of the interior of the church, for instance, or to light a speaker and record some background light in a big room.

Use TTL flash combined with speeds of ⅛, ¼, ½, or even longer, and appropriate lens apertures, of course, for the technique known as "panning"—following movement with the camera. The short flash burst hits and "freezes" silhouetted, moving subjects nearby—in bright streets, for instance. The long exposure records background lights out of flash range as streaks or blurs. Vary apertures and shutter speeds (but remember never to go above flash synch speed), while still using flash in TTL mode, for different effects.

Slow Synch requires practice. You will probably get many unusable images at first, but persist. Successful shots can be great.

With all Slow Synch techniques, use a tripod to control camera shake and minimize background blur!

A pop-up flash was used to make the girls stand out from a dull, gray day. Stand close to minimize possibility of red-eye effects.

Automatic Flashes

Manual camera users should buy an adjustable automatic type of flash, such as the classic Vivitar 283 or an automatic Sunpak or Metz flash. *Note:* Do not confuse automatic flashes with the Auto Flash setting on consumer electronic cameras—those fire flash even if the subject is impossibly distant.

All automatic flashes control exposure with a sensor on the front. To use,

This is the color-coded circular exposure scale on the classic Vivitar 283 flash. This particular model gives a choice of four f-stops or four distance ranges. If the film speed (or ASA, as marked on this flash) is set to ISO 100 and you choose f/11, for instance, you can shoot between three and ten feet away. (See flash manual for more details.)

An old picture of my daughter with her grandfather, made with a Vivitar 283 automatic flash mounted on a tripod and bounced into a twenty-four-inch white umbrella. The flash was connected to the camera by Vivitar's automatic cord. Using ISO 100 film, I set the film speed on the camera and the flash and aperture to f/8 and, allowing for the umbrella's reducing the flash range, worked within five feet of the subjects.

you must first set the ISO speed on camera and flash. Then choose either a lens aperture you want to use or a distance range you want to work at. Set either on the flash scale. Set the required lens aperture, as well as any shutter speed at or below flash synch, on the camera. (See pictures of a Vivitar 283 and typical Sunpak flash scale on page 69, and refer to your flash manual.) After you have completed the setup, work within the required distance range, and the flash will cut out when enough flash hits the subject for a good exposure.

Try the Slow Synch techniques described on pages 66–67 with an automatic flash and a manual camera. My Vivitar 283 flashes handle slow synch exposures, up to about one second, quite well.

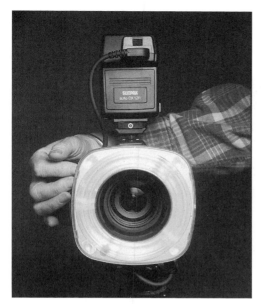

Ring lights fit around lenses and throw a narrow, soft shadow all around a subject. Sunpak's low-powered ring flash is designed for extreme close-ups and is popular with nature photographers, dentists, and medical specialists. Fashion photographers especially favor powerful ring lights. Norman and Hensel make battery-operated ring light heads, and Calumet and Profoto are among strobe manufacturers offering this option.

Sunpak probably makes more flash models than any other manufacturer. Their automatic/manual units are set via a color-coded sliding scale on the back. The 120 GN unit shown here offers a choice of three f-stops or distance ranges in Automatic mode. With ISO 100 film at f/4, you will get good flash exposures at distances of between four and thirty feet. See camera buying guides and photo dealers for up-to-the-minute Sunpak model numbers and features, and see flash manuals for details on operating specific flashes.

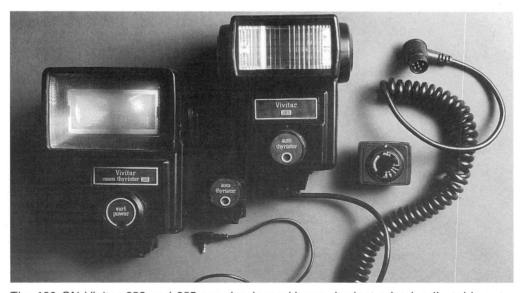

The 120 GN Vivitar 283 and 285 are classic workhorse, budget-priced, adjustable automatic/manual flash units that have been in production for many years. Both can be used on- or off-camera, with the synch/pc cord provided or with optional remote cords. At fairly close distances these flashes can substitute for or augment strobe lights.

Manual Flashes

Irrespective of size, all manual flash units, as well as all TTL and automatic flash units used in Manual mode, put out the same, fixed amount of light each time fired (if fully recycled). In my opinion, there is not much point today in buying a tiny manual flash, as low-powered adjustable automatic/manual flashes can be had for under $20.

Professional manual flashes can be mid-priced and mid-powered or as powerful and expensive as top strobe units. All are powered by rechargeable batteries or battery packs. (Some portable flashes have optional AC adapters).

Dyna-Lite, Lumedyne, and Norman are well-known brands of mid-power professional manual flashes; still, my choice is Quantum's mid-power TTL/Auto/Manual Q flash (model numbers change) with a battery pack.

The highest-power manual flashes cost from about $2,000 and up. Some users include top advertising, fashion, travel, and location photographers. Such expensive flash units are outside the scope of this book, but Comet and Hensel are two well-known brands. (See appendix B for more information.)

Metering Manual Flash Exposures
Inexpensive reflected-light flashmeters are made by Wein for about $75; they

Luis Mendes is a well-known New York street photographer who is a master of flash. He uses a customized Graflex camera and a flash that takes bulbs. His medium is Polaroid film and he exposes by experience. I ran into him in a snowstorm, and he graciously let me take his picture. I know I used a Nikon N-90 and SB-26 flash, but did not record the exposure at twilight. Note how my flash "stops" the snowflakes.

measure flash only (see appendix B on page 158).

I recommend using an incident-type flashmeter. These versatile meters are an investment—they cost from about $250–500 and can measure flash, strobe, daylight, studio hotlights, or a combination of these. For much more on this, see the Exposure and Metering section, starting on page 38.

Determining Manual Flash Exposures with the Guide Number Formula

Manual flash exposure can be calculated mathematically without a flashmeter, if you know the flash Guide Number. To find the f-stop needed for correct exposure, divide the distance from the subject into the Guide Number. Use the f-stop closest to the resulting number—a GN of 120 means you need an aperture of f/11 at ten feet; a GN of 80 calls for f/8 at ten feet.

Or, to base your distance from the subject on a predetermined f-stop, do the reverse: With a GN of 120 and an f-stop of 8, you want to stand fifteen feet from your subject—120 divided by eight is fifteen—so place your flash fifteen feet from the subject.

Now, there are two key determinants to keep in mind: unit of measure (feet or meters) and film speed. Most flash manuals provide two Guide Numbers—one for feet and one for meters. However, if your film speed is greater or less than 100, you must refer to your camera manual in order to adjust the Guide Number to the appropriate factor.

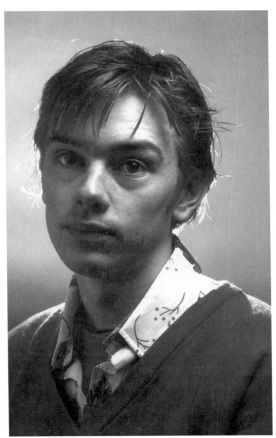

This young Irishman was photographed with three battery-powered Vivitar flashes used in Manual mode. Exposure was determined with an incident light meter. One flash on a low light stand behind the young man was aimed up—some light caught his hair, and some hit the background. The main light was about four feet to the right, and slightly above subject, bounced out of a white umbrella. The fill light from the left was bounced off my white studio wall, about eight feet away. Exposure was basically 1/60 at f/8 on ISO 100 color film, here transposed to black-and white.

Using Flash as Studio Lighting

To use any flash with a "foot" on a stand, buy a ProTech flash umbrella mount device (about $20). The flash then must be connected to the camera via a long "synch/pc" cord (flash synchronization cord) or a "trigger and slave" combination on camera and flash.

Adjustable flashes normally do not have modeling lights. Use a small flashlight taped on top of the flash to help you aim lights accurately. (Or, if your money is burning a hole in your pocket, some professional flashes with optional AC cords do offer a head with a modeling light.) Meter manual flashes with a flashmeter as you would a strobe. (See also the Exposure and Metering section on page 48, as well as the Lighting with Strobes section on page 83, for more on this topic.)

Carefully used, off-camera flashes aimed through fabric "soft boxes" or "bounced" off or shone through umbrellas can stop motion and give lighting effects similar to low-power strobe lighting.

Used very close to a subject, manual flashes in the studio can achieve strobe effects if don't yet have a strobe budget.

Nikon's SB-26 TTL flash has a built-in slave and can be used remote in Automatic mode, triggered by an on-camera TTL flash. Buy it used.

Remote Flash with Triggers and Slaves

Ikelite makes the useful "Lite-Link" slave stand for remote Nikon or Canon flashes. The Lite-Link is triggered by the flash on the camera and mimics the on-camera flash. Provided the slaved flash

Two customized 120 GN Vivitar 283 flashes in manual mode, both fitted with Wein slaves and triggered from the camera, lit Derek's portrait. The background flash was customized to take a round reflector and further modified with frayed aluminum foil, which softened the edge of the light. The second flash was used bare-bulb and aimed from two feet behind the subject, backed by a twenty-four-inch Westcott silver umbrella instead of a small metal reflector. A flat silver reflector just out of camera range in front of the subject completed the setup. Exposure on ISO 100 film was 1/60 at f/11.

is further from the subject than the TTL flash on camera, the second flash works fine as a fill light.

Infrared "multichannel" trigger/slave combinations are used in places where other photographers—pro or amateur—are sure to be flashing away, at weddings and news events, for instance. You change the channel to avoid interference. Calumet, Quantum, and Wein make such units with two or more channels.

Radio-controlled triggers and slaves with many channels can be used to con-

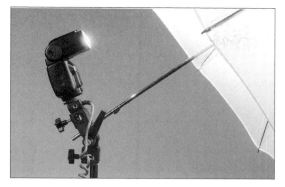

A flash can be set on a stand and aimed into an umbrella to bounce or diffuse light with the aid of ProTech's umbrella mount device (it costs around $20). The flash can be slaved or used close to the camera connected with a TTL cord.

trol large numbers of flash units at up to considerable distances. Wedding photographers can work with one or more assistants who carry remote flashes on light poles for fill light. Pocket Wizard is the best-known maker of multichannel radio-controlled units.

Note: Even the best triggers and slaves are not 100 percent interference-proof. Two or four infrared channels may not be enough to prevent interference from all other flashes at a big news event. And I have heard of cleaning ladies' vacuums and secret service agents' radios being among sounds that have set off radio-controlled strobe lights! Contact photo lighting dealers to find out what's best for your needs and budget. To contact manufacturers, see appendix B, on page 158.

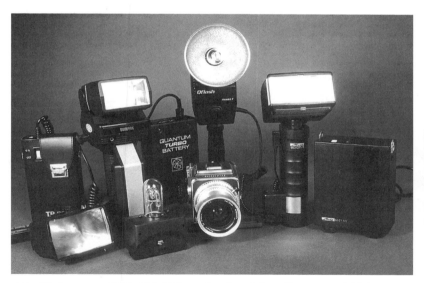

LEFT: High-power (160–190 GN) professional, handle-mount, TTL/automatic/ manual flashes with separate battery packs are favored by wedding photographers especially. From the left, these are by top independent makers Sunpak, Quantum, and Metz. All accept modules to interface with different brands of 35mm and medium-format TTL electronic cameras. An option is that reflectors can be removed or exchanged for "bare tube" flash use. My choice is the Quantum. See dealers for up-to-the-minute model and pricing information.

RIGHT: This Pocket Wizard Multi Max is used in pairs to fire remote flashes, strobes, or cameras at distances of up to 1,600 feet and can be set for intervalometry—photography at timed intervals—too.

This picture was exposed for daylight in camera's Shutter Priority (S) mode. Fill from the on-camera adjustable flash angled up was bounced off the flash's built-in white bounce card.

 # Flash Essentials — A Summary

Flash Synchronization, or "Synch"

Your camera shutter must be set to flash synchronization, or "synch," speed (or any speed below synch) when shooting flash or strobe pictures, or part of the image will be blacked out or dark—out of synch. Learn your camera's maximum synch speed from the manual. On older cameras, it will be marked on the shutter-speed dial in a different color or with an X, or both. Most, though not all, electronic cameras will not fire if the flash is turned on and the camera is out of synch.

Common Camera Synch Speeds

- $\frac{1}{30}$ of a second is maximum synch speed for Pentax 6 × 7 SLR cameras.
- $\frac{1}{60}$ of a second is maximum synch speed for old manual 35mm SLR cameras.
- $\frac{1}{60}$ is maximum synch speed for Hasselblad cameras with focal plane shutters.
- $\frac{1}{125}$ is maximum synch speed for intermediate-age 35mm SLR cameras.
- $\frac{1}{125}$ is synch speed for the Fuji S-1 digital SLR camera.
- $\frac{1}{200}$ is synch speed for the Nikon FM-2 35mm SLR mechanical camera.
- $\frac{1}{250}$ is synch speed for many modern 35mm electronic and digital SLR cameras.
- $\frac{1}{300}$ is synch speed for a few top-of-the-line 35mm SLR cameras.
- $\frac{1}{500}$ is maximum synch speed for all cameras and lenses with leaf-type shutters. See your manual for more on this.

Flash Falloff

The light from a single flash, or any single-point light source, *falls off according to the square of the distance from the subject*. For instance, if correct exposure at four feet is f/11, at eight feet, it is f/5.6, not f/8. Maximum flash ranges claimed by manufacturers are achieved at the widest possible lens apertures. You cannot flash the ball-game from the bleachers, ever. For best effects, shoot flash pictures at a range of between four and fifteen feet. Remember that all flash light modifiers reduce flash range—most by two f-stops. Choose the highest possible synch speed when using "flash fill" to lighten shadows on faces or close objects in bright sunlight.

Setting Flash

When first using a TTL flash with a compatible TTL camera, set Program camera mode and TTL flash mode to get very good results. Use Shutter Priority camera mode and set slow shutter speeds when shooting in big, dim rooms or out of doors at night to record background lights out of flash range. Many electronic film and digital cameras offer a Slow Synch (or similar name) flash mode as an option to get these effects. Set an adjustable electronic TTL-metering film or digital camera to Manual mode, and set a dedicated flash set to TTL mode. The slower the shutter speed, the more background light will record, and the less flash will be needed. Using ISO 100 film or digital setting, try $\frac{1}{30}$ or $\frac{1}{15}$ shutter speeds at f/4 or f/5.6 as a start.

Lighting with Strobes

 # Safety Precautions with Strobes — Read Carefully!

- Strobe packs draw household AC current but transform it to high voltage. Using a strobe improperly can cause severe shock.
- After shutting down any strobe, immediately discharge unused high-voltage power stored in both power pack and strobe head by pressing the strobe's "test" button. (Most modern strobes self-discharge, but don't take this for granted.)
- Never remove a strobe head from its pack when the strobe is plugged into the AC. First, turn the strobe off, then discharge stored power, then disconnect from AC, then disassemble and pack for travel, if needed.
- Never jerk extension cords or cables for light heads out of AC sockets or strobe power packs. Remove them gently, grasping the plugs.
- Disconnect all strobe head and strobe pack cords and cables by the plugs at each end.

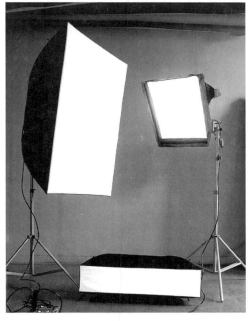

I own three collapsible black-backed soft boxes that give an even, virtually shadowless light. I like Chimeras. The 3 × 4 foot model is big enough for full-length figures or for imitating window light. The 16 × 20 inch model concentrates light for portraits and can be used over a strobe head or a flash. The 12 × 36 inch strip box casts a narrow beam if used vertically and spreads light if aimed horizontally.

SOFT LIGHT BOXES—AND AN IMPORTANT SAFETY NOTE

"Soft boxes" are popular light modifiers. Black-backed fabric "soft light" boxes with translucent white front panels are made with adapters for different strobe heads by a number of manufacturers. When a strobe head is shone through a soft box, the result is a highly directional light with soft, deep shadows. The light does not "spill" onto surrounding areas and is good for portraits and still-life subjects.

Note: Most soft boxes are made for use with strobes or flash units. Never, ever, use those with hotlights, or you may start a fire.

Photoflex makes a hotlight called the Starlite and fireproofed fabric soft boxes. If you want to use a soft box but must use a hotlight, this is the combination I recommend.

An Introduction to Strobes

Professional strobes are powerful, permitting the use of small lens apertures for excellent "depth of field" (zone of sharp focus), and the burst of light they emit is brief enough to "stop" or "freeze" most motion. Also, all modern strobes are color-balanced for daylight film and digital camera settings, so strobe can unobtrusively be blended with daylight. And far more accessories and "light-modifying" devices are available for strobes than for other forms of photographic lighting.

Strobes are the lights to invest in if you are deeply committed to photography or have serious artistic needs or professional ambitions. It will take you a little time to get up to speed lighting with strobes if you have not previously used hotlights, but it can be done successfully if you first carefully read manufacturers' instructions and absorb the lighting fundamentals and principles starting with the first section of this book.

Strobes can be used with all adjustable film cameras and with all user-adjustable "single-pass" professional digital cameras.

Strobe Components

Most strobes consist of a power pack that must be connected to a continuous AC "mains" power supply. The typical pack has outlets for two to four "light heads," incorporating flash "tubes." The heads connect to the power pack by electric cables. "Monobloc" strobe units are one-piece. Power pack and light head are combined and plug directly into an AC outlet, via an extra-long cord.

Strobe light heads can be of various

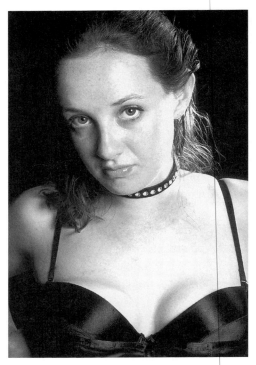

A two-light portrait of Daisy. I used a 1,200 WS (watt-second) Profoto strobe turned to half power with two light heads equally balanced. For the main light, one head was aimed through a 24 × 36 inch white, translucent, black-backed Chimera soft box to give a directional light with soft, dark shadows. The second strobe head, covered by a snoot to concentrate the light, was attached to a boom arm; it hung about five feet above her head and was angled towards her from camera right to give a hair light.

designs. The strobe tube itself contains wires sealed into a glass or quartz envelope filled with xenon gas. There is also a 100 watt or 250 watt tungsten "modeling lamp" that burns continuously when the strobe is turned on. The light head assembly is protected with a glass or quartz cover and connects to the power pack with a power cord.

A "synch cord," or flash synchronization cord, running from camera to power pack or monobloc fires the strobe when the camera shutter release is

depressed. Strobes can also be fired without a synch cord, using some kind of "trigger" device on the camera and a "slave" device that receives a signal and fires the strobe. (For more, see later in this section, as well as Remote Flash with Triggers and Slaves, on page 72.)

How Strobes Work

Strobe packs continuously draw current from a "mains" AC electricity supply, and devices inside the strobe pack convert low-voltage electricity to a much higher voltage. The high voltage current is stored in "capacitors" that look like large flashlight batteries. When the strobe is fired, by an electronic or other signal from the camera, the stored high-voltage current immediately passes through the wires in the tube. This "excites" the xenon gas, causing it to emit an extremely brief, bright flash of white light.

A great value of strobe is that the xenon gas reverts to its natural state almost immediately after use; then the strobe is ready to be fired again. Strobes recycle quickly—the exact time varies with make and model, but is usually about 1.5–3 seconds on full power. Strobes can recycle at this rate for hours at a time if needed.

The duration of a strobe flash of light is extremely short, from about $\frac{1}{350}$ of a second at full power, $\frac{1}{1000}$ at half power, $\frac{1}{4000}$ at quarter power, and lower still if the power setting can be further reduced. This means that strobes (like small flash units) can "stop" or "freeze" much motion and render moving subjects without any blur. Specialized strobes can record movement not visible to the naked eye.

A great value of strobe is that the light emitted is white, extremely close in color to neutral noontime daylight, with a color temperature of 5,500 degrees Kelvin (5,500°K). Therefore, strobe can be mixed with daylight, and daylight-balanced films are used with strobes. If you are using strobes with adjustable digital cameras, Daylight White Balance settings should be selected.

Strobe is not for use with amateur, nonadjustable electronic film or digital point-and-shoot cameras that do not have a "hot shoe" on top or a synch/pc cord outlet on the front. Nor is strobe compatible with professional digital cameras with "three-pass" scanning backs. (Non-user-adjustable electronic cameras will work fine with tungsten hotlights; see pages 7 and 47.)

BUYING A STROBE

If and when you are ready to invest in a strobe, you will need a few hundred dollars minimum, or you can spend several thousand.

Don't buy a no-name strobe. Talk to a good photo lighting dealer, and compare several strobe brands' features and prices before investing. Also, refer to Upgrading from Rock-Bottom-Budget Lights on page 15. A couple of lighting dealers I can personally recommend are listed on page 158, in appendix B.

The controls are self-explanatory on the Profoto Compact 300 monobloc strobes that I use. They are "self-slaved," which means that they can be fired by a remote flash or trigger light on the camera, if no synch/pc cord is inserted. They can also be fired by a synch/pc cord from camera to strobe. (See page 83 for more on synch/pc cords.

This is the same Profoto Compact 300 monobloc stobe, viewed from the front— the removable reflector can be replaced by another of a different finish, for a slightly different "look."

The controls on the Profoto Acute 2,400 WS power pack.

The Profoto Acute 2,400 WS strobe pack.

The AC cord and up to three heads plug in on the side of the 2,400 WS unit. All heads accept all the light-modifying accessories offered for the Profoto system.

My Own Strobe Preferences

I use a 500 WS Dyna-Lite pack with two heads on location—these units are rugged and compact. Most often, I aim the strobe head into a thirty-six-inch white umbrella, reversed so it "bounces" soft light onto the subject.

I work with a Profoto pack with two heads plus two Profoto monobloc (one-piece) units in the studio. I bounce this light off opaque white or sometimes silver umbrellas, or I shoot them diffused, by aiming them through translucent white umbrellas or black-backed translucent soft boxes.

Strobes require manual metering for reading exposures, so a good flashmeter is essential (see Incident-Light Meters on page 48).

Also needed is a way of firing the strobe from the camera. A "synch" (flash synchronization) cord, also known as a "pc" cord, is an inexpensive device. A

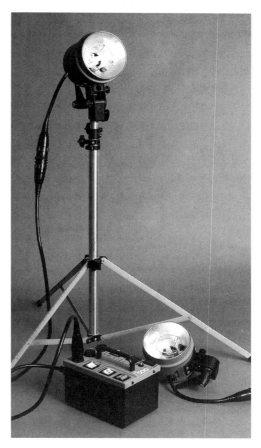

My 500 WS Dyna-Lite power pack and two heads. Dyna-Lites have been workhorses for location shooters for years—I can easily fit this outfit plus two Manfrotto light stands, two twenty-four-inch white umbrellas, a flash meter, slaves and trigger, and a twenty-five-foot extension cord into a standard twenty-four-inch rolling carry-on bag.

Dyna-Lite tubes are recessed in nonremovable reflectors, are easy to pack and inexpensive to replace, but do not offer much versatility. Now, Dyna-Lite also offers a head with a standard tube and removable reflector, so bare bulb and other options are available to Dyna-Lite users.

synch/pc cord made by Paramount and others will cost under $20. One end plugs into the strobe outlet on the camera (or into an outlet on Wein's Safe Sync device set on a camera hot-shoe). The other end of the synch/pc cord plugs into the strobe, firing it when the camera shutter is depressed.

TOP: Two heads were used with a 500 WS Dyna-Lite strobe pack, placed eight feet high and spaced about fifteen feet apart. The lights were bounced off thirty-six-inch white umbrellas, so that soft light lit this long, narrow room (below). I checked to be sure the illumination was even with the aid of an incident-light meter. A tripod-mounted Fuji S-1 digital camera with a 14mm lens was set at ISO 400. Exposure was 1/30 at f/5.6.

BOTTOM: Miriam Navalle at T-Salon restaurant in New York. Lighting data illustrated in top photo.

Light Modifiers and Other Strobe Accessories

Strobes offer the widest possible range of light modifying accessories—too many to discuss or even to list them in this book. Visit a good light dealer, or better yet, a photo expo, even if you don't plan to buy any accessories yet. You will learn a lot. If neither possibility exists, get a good catalog—from Calumet, for instance. (See appendix B for more on where to find strobes.)

Barn Doors

Barn doors, which I've mentioned in earlier chapters, are thin metal flaps that attach to strobe reflectors and can be opened or closed to control the spread of light. Barn doors will prevent unwanted light from spilling onto a subject.

Grids

Grids of different angles are available to fit most strobe systems. They concentrate light. See the photos below and on page 87.

Booms

Booms are the arms that attach to light stands so that a light can be hung over a person or set. They are often used to provide a hair light, as shown on the front cover of this book.

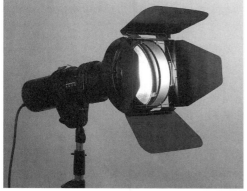

The same monobloc unit as the one shown on page 82, used with barn doors and seen from the side and back.

A grid inserted in a reflector, and two of the several different angles of grid available. The narrower the angle, the denser the grid and the narrower the spread of light.

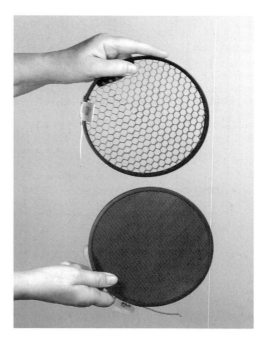

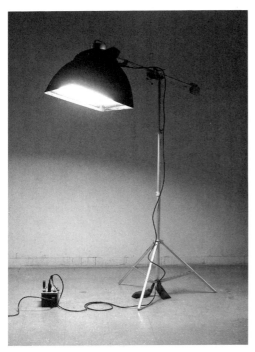

A light can be hung on a boom arm over a set. Here, I'm using a small soft box, hung on a Lowel boom. With any boom, you must always weight the arm opposite the light, as well as the bottom of the light stand. On the cover of this book, a snoot, creating a narrow beam for a hair light, is hung from a big Manfrotto boom arm and stand.

Firing Strobes with Triggers and Slaves

A trigger unit on the camera can set off one or several strobes equipped with "slaves" without the need for a physical connection via a synch/pc cord. In a studio, this means that you do not have to rearrange wires every time you move lights. On location, it means that you can fire flashes or strobes from a considerable distance.

I use a small Wein XXR infrared trigger on my camera hot-shoe. The flash burst it emits is invisible, so it does not create an unwanted hot spot in pictures, as a conventional flash used as a trigger can.

I, like many other professional photographers, use and swear by Wein triggers and light-activated slaves. The slaves can be attached to flashes and strobes and come in different sizes, degrees of sensitivity, and prices. I use them indoors and out, because I don't usually work in crowds where others are shooting flash.

Light-activated trigger/slave combinations are normally best used in studios or at remote locations where other flashes won't interfere. (If other flashes are being used, your slaved strobes or flashes will be fired when anyone around you takes a flash picture.)

Multichanneled, infrared slaves and triggers are favored by wedding photographers. Multichanneled, radio-controlled trigger-and-slave combinations protect from other flashes' interference in extremely busy locations where other professional photographers are working. Sports specialists may wire a whole arena with radio-slaved strobes, so that they alone can capture motion-stopping basketball or hockey shots.

Using any trigger/slave combination will reduce cord clutter on a studio floor. Wein, Calumet, and Quantum market light-activated and infrared trigger/slave combinations; Pocket Wizard makes sixteen-channel, radio-controlled slaves.

Also, see the discussion of triggers and slaves in the previous section, on pages 72–73.

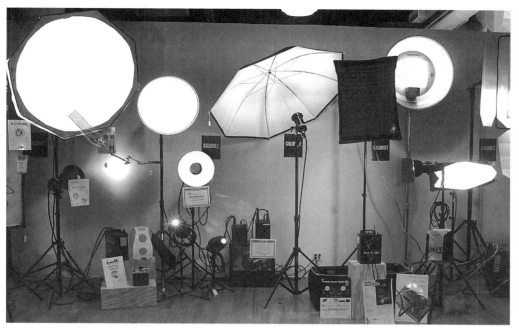

A wide choice of light modifiers is available for strobe units. Shown are various sizes and shapes of soft boxes and umbrellas. The dark rectangle is a soft box fitted with a fabric grid. Also shown are a ring light head, two optical spot attachments, and a small tent. I took this picture by courtesy of Calumet, New York.

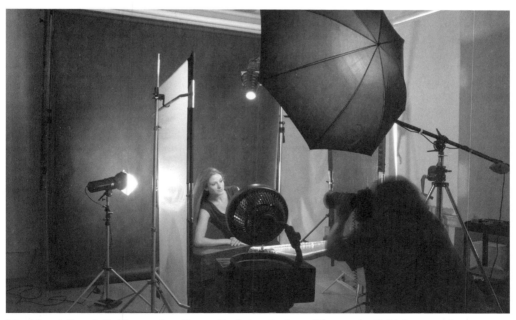

My friend Karol DuClos using three Profoto strobes. The main light is on a boom arm attached to a professional Manfrotto light stand, and bounced out of a 48 inch white black-backed umbrella. The hair light is a monobloc strobe with the light beam narrowed by a cone-shaped snoot. The fill light is a monobloc aimed through a California Sunbounce diffusing panel, and further diffused with fiberglass. With a ISO 400 digital setting, and my camera on a tripod I exposed this shot at ¼ at f/8. I chose to use the strobes' modeling lights as the only light source, in order to record the ambient light in the studio.

Nine Self-Assignments

Introduction to the Self-Assignments

The purposes of the assignments are: (1) to give you ideas; (2) to give you plenty of practice in setting up and adjusting lights for different types of subject matter; and (3) to familiarize you with real-world picture needs. You might well be able to earn money if you can do these shots competently. If you can make some great images from this type of material, you will have the basics of a professional portfolio.

If you find your first picture efforts with setup lighting a bit disappointing, don't dream of giving up. Do the pictures over, more than once if necessary. Then try my approaches with your own choice of subjects.

If you want to photograph babies and you have access to them, try all the suggested lighting techniques just on babies. You may come up with a unique lighting "look." Or try all the various techniques on still-life subjects or on rock musicians. You get the idea.

You will soon find whether you prefer the look of hard or soft lighting on your favorite subjects, and if one or several lights usually best creates the mood you want to achieve. Learning preferences means you are approaching having your own "eye" and your own lighting style. To refine this eye and further refine your style, keep shooting, of course, and also study the work of some lighting masters—painters; commercial, editorial, and fine art photographers; and also cinematographers—even study the work of the highly talented and highly paid people who make great television commercials. I like to look at how those are lit, but usually with the sound turned off!

A 500WS Dynalite strobe in a 36 × 48 inch black-backed Chimera soft light box was used to make the pictures of bread and eggs. In both cases the strobe was on a boom and hung about four feet above the subject. It was aimed from the right on the bread and from above and slightly behind the bowl of eggs. Exposures on ISO 100 film were basically the same, 1/60 at f/16, and I bracketed, especially on the eggs.

Self-Assignment 1: A One-Light Portrait

Make a portrait showing a subject's face and his or her hands.

Use one light on a stand, plus a white umbrella if desired, and a reflector to fill shadows. Use one photoflood or quartz hotlight, or a strobe or flash off-camera, as desired.

Approach

The model can be of any age, race, or body type. A colleague who is a great portrait photographer once said to me, "If you can't make someone look handsome or beautiful, you can always make them look interesting." Try to bring out your subject's best features always—lighting helps a lot. Soft lighting flatters almost everyone. Light with strong shadows can be good for men and sometimes for the "beautiful people," too.

Use a longer-than-normal lens or zoom lens of your choice—wide-angles don't flatter faces. I love an 80mm lens for portraits, but this is not written in stone; other photographers have other favorite portrait lenses.

As with the photograph on page 16, I used one 250 watt, 3,200°K ECA photoflood lamp in a ten-inch Smith-Victor reflector with a soft aluminum finish. The model was three feet in front of a light gray background. The light was placed at "high three-quarter" position: about two-and-a-half feet to the front and left of the model, six feet high, and two feet above and aimed down at her head. Then, I hung a thirty-six-inch silver reflector opposite the main light to reflect light onto the dark side of the subject, from two feet away. I used an 80mm f/1.8 Nikkor lens. The ISO setting on my Fuji S-1 digital camera was 400; exposure by the in-camera meter was $\frac{1}{180}$ at f/4. The camera was on a tripod.

Self-Assignment 2: A Still Life of Nonreflective Objects

Make an arrangement of nonreflective objects. Light it with a combination of lights and reflectors. The theme is "my favorite souvenirs." Or, if you prefer, group any collection of objects that are somehow related to each other.

Approach

Use any type of light and light modifier you please, plus a tripod.

To begin lighting, aiming the light down from a 45 degree angle onto most subjects works well. Then try sidelighting and even backlighting. Use light aimed direct for a hard, shadowed effect or bare bulb without any reflector for distinct, pale shadows. Shine light through or bounce it off a white umbrella if diffused light is desired. Fill shadows with a reflector placed opposite the main light; move this in or out to lighten or darken fill. Remember, a silver reflector gives a lot more fill light than a white one.

With any still life, work with the camera on a tripod and, continuously stopping to view through the lens, carefully place the objects as you want them. Having an assistant to place objects while you look through the lens will save you much running back and forth.

The still-life background can be plain, "no-seam" photo paper, a plain wall, or appropriate fabric. Or it can be related to your subject—a beautiful dressing table for jewelry or a workbench for a collection of tools, for instance.

Assorted Disney collectibles photographed with Sunpak's Ring Flash. Exposure was ¹⁄₆₀ at f/4.5 on ISO 100 film.

This picture was made with one 1,000 WS strobe with one head that was bounced out of a forty-inch opaque white umbrella placed in the high three-quarter position about four feet above and two feet to the left of the table. Exposure by flashmeter was ⅟₃₀ at f/16 on ISO 25 film. I bracketed with the f-stop. The slow shutter speed burned in the candle flame and low existing lights.

Self-Assignment 3: A One-Light Close-Up

The skills you'll acquire during this assignment are perfect for photographing objects you'd like to sell on the Web. You'll need one light and a small reflector.

Approach

To focus as close as you can, it's almost essential to use a tripod. Depth of field (zone of sharp focus) is extremely shallow with close-ups. The tripod will enable you to set a slow shutter speed and small lens aperture to maximize depth of field and avoid camera shake. *Tip:* Use manual focus on extreme close-ups. On program film and digital cameras that do not contain an interchangeable lens, use the Macro mode, if available.

Most modern lenses and cameras permit focusing close enough to fill a frame with an average-size rose. To get even closer, relatively inexpensive close-

This angel, about six inches high, was shot for a catalog using one strobe head set to 250 WS inside a small soft box aimed from above and to camera right of the object. There were a great many items to shoot, so I worked with an assistant, in an assembly-line technique. The camera was on a tripod, and I used an old, extremely sharp 60mm Macro Nikkor lens from the 1960s. Exposure on ISO 50 film was ¹⁄₁₂₅ at f/22.

The antique glass pig is an heirloom belonging to a friend. I lit it from underneath, to show details without ugly reflections. (See page 110.) Any piece of glass or stiff plastic works well for this technique. Cover the glass with purpose-made Kodak Ektalite sheeting, artist's vellum, or tracing paper. Exposure was not recorded.

up filters fit over lenses, and "lens tubes" can be inserted between lens and camera bodies. Macro lenses can be used for bigger-than-life-size close-ups. Check manufacturers and photo dealers.

Light a close-up to show the subject's texture and modeling. Then vary the angle of the light. Remember that sidelighting emphasizes texture and backlighting is good on translucent subjects. Angle light carefully to avoid "hot spots" on shiny objects.

Two valuable American folk art figures were shot with permission in a museum in Pennsylvania. The client was a textbook company. I carried my own half-roll of no-seam paper and lit the objects with one strobe bounced out of an umbrella. The light was from camera left, and exposure was 1/125 at f/16–22.

This multi-goblet still life was lit from underneath with a 500 watt flood lamp aimed through a Plexiglas sheet covered with draftsman's tracing paper. I needed to show the glasses accurately, but also looked for pleasing patterns of overlapping glass to make the shot interesting. Digital exposure at ISO 400 was 1/60 at f/11.

A 250 watt photoflood lamp in a garage light reflector was bounced out of a thirty-inch white umbrella to light these small objects. The nine-inch-high statuette of Shakespeare was on a table, with light gray, no-seam paper taped up behind him. The light was about two feet to camera left and about three feet above the object. The old industrial thermometer was lit from the right. I took care that no glare reflected from its glass face. Exposure for both was ¹⁄₆₀ at f/11 on ISO 100 film. Use this budget setup to light items you want to sell on the Internet—at sites like eBay—with just about any electronic film or digital camera or any adjustable manual camera.

Shoot any flower or fruit, or a coin, medal, stamp, piece of jewelry, or "collectible" object you might want to auction on e-Bay.

Alternatively, move in for a close-up of a person's eye, nose, or ear, or a baby's feet or fingers. Shoot a prize-winning slice of pie, or a detail of a handmade model airplane or boat, or choose any object of interest—you get the idea.

This Valentine candy close-u p was laid out on no-seam paper on the floor and lit with a 250 WS strobe head shone through a 24 × 36 inch Chimera black-backed fabric soft box. The diffused light was aimed from about four feet above and two feet from the right of the subject. I stood above the still life and used a 60mm macro lens to render the candies about 50 percent larger than life. Exposure on ISO 100 film was1/60 at f/16–22.

Self-Assignment 4: A Figure or Movement Study

Make an artistic full-length figure composition of a person, or two or more people, against a plain wall or no-seam background. The subject can be still or moving. (Here is an opportunity for you to try your camera with the draped and undraped human form—it has been one of the favorite subjects of painters, sculptors, and, more recently, photographers throughout the history of art.) This self-assignment is strictly meant for yourself and not for commerce. I want to loosen you up. Try any conventional or experimental approach you like, with any lights. Show the whole subject, not a detail at first; move in later if you want to.

Remember that in art, there are no absolutes. Your subjects can be fat or thin, young or old, clothed or unclothed; gracefully reclining on a couch, sitting dignified in a chair, standing on their heads, or sound asleep in bed.

Equipment: Two lights and three stands, with light modifiers of your choice. A tripod if shooting under hotlights. A flashmeter and synch/pc cord if you are using a manual flash or strobe or a TTL cord if you are using TTL flash.

Approach

If this is an action shot of, say, people dancing or musicians playing, use either flash or strobe to stop motion. To

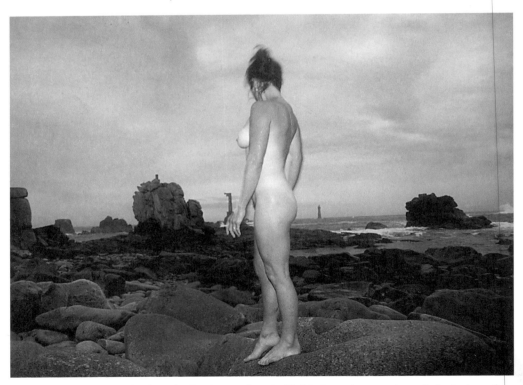

Nude woman on rocky beach. In deepening twilight, I made a series of shots in a few minutes with the camera on a tripod and a TTL flash on the camera. Exposure with ISO 100 film was ¼ at f/4.

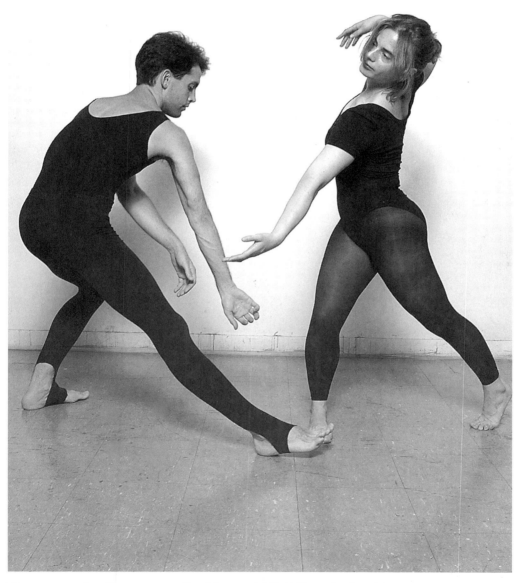

The two moving figures were lit with one 1,200 WS strobe head bounced out of a fifty-inch white umbrella mounted on a boom arm and aimed down at the subjects. (The photo on the cover illustrates this.) I shot quite a few pictures to get a composition I liked. ISO 400 digital exposure was 1/60 at f/11.

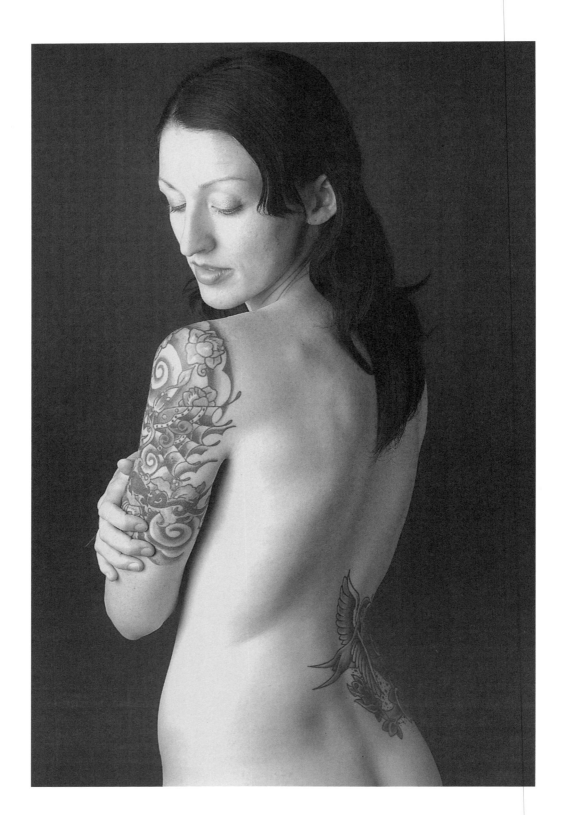

photograph figures seated or lying quietly, any hotlight is suitable.

Think about shadows on the background—to avoid these, keep subjects well away from the background, raise the light or lights high on stands, or perhaps use one light to light the background.

Bounce the main light off white walls or ceiling, or tape up white cloth, paper, or even aluminum foil and bounce light off that. Or bounce the light off a big white umbrella. If you want shadows, use lights without diffusing them.

Work with your camera on a tripod if your light source is 500 watts or less,

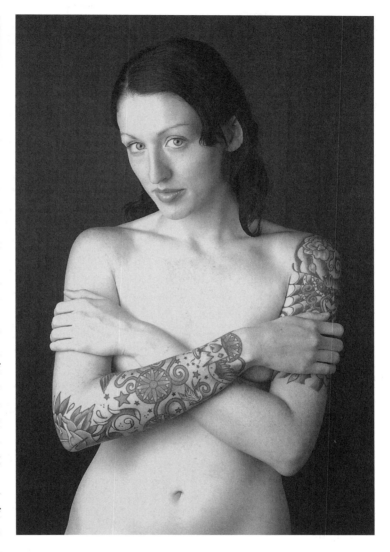

because then you may have to set fairly slow shutter speeds. "Bouncing" light around a white or light-toned space means it kicks all around the subject, giving a soft, almost shadowless look.

These two pictures were both lit by one Dyna-Lite strobe used at half power (250 WS). The head, diffused by a 36 × 48 inch black-backed soft box, was aimed from the right about three feet from the subject. Two California Sun bounce reflectors were angled from the same distance at left to provide fill light. Big soft boxes give a very gentle, even light, especially when used close to a subject with low-power lighting. I like this effect on the human form. Digital exposure at ISO 400 was 1/60 at f/16.

Self-Assignment 5: People in a Location Setting

Show one, two, or several people in a restaurant, office, school, hospital, shop, barn, or other interesting setting you have access to.

Light the room, or at least part of the background, as well as your subjects. Turn any existing lights in the room on.

Essentials and equipment: This typical location lighting assignment will require two, three, or four lights, depending on the size of the area you must light. Strobes are ideal, but hotlights will work if the people don't move fast. Small flash is not a great choice for this assignment, but several professional battery-powered flashes will work well. You will need to pack up and carry a tripod, light stands, the light modifiers of your choice, and possibly, a big white or silver reflector or reflective surface, plus extension cords, clamps, and gaffer tape. One or two good bags are a necessity. I use Tenba backpacks and light cases.

If using strobes or pro flashes, a camera trigger plus slaves for each unit are essential, as is a flashmeter. If this is a professional shoot on film, a Polaroid camera or Polaroid back for your camera plus Polaroid film for making test shots will be extremely helpful.

For digital images under hotlights, you can easily shoot tests with program or manual camera settings. Meter from your camera, view effects, and adjust exposures if needed by studying test images played back on the camera LCD screen. *Caution:* Be sure that you hold

Morris Mini self-slaved flashes are small and round and can even be left on view to mimic light fixtures quite successfully. Digital exposure here at ISO 400 with an on-camera flash in TTL mode was ⅟₃₀ at f/8.

This location portrait of a chef was made in a busy hotel kitchen. A 500 watt Smith-Victor quartz light, bounced out of a twenty-four-inch white umbrella, was quick to set up. I gaffer-taped the stand to the steel counter at camera right. The exposure on film rated at ISO 800 was 1/125 at f/4–5.6. As this shoot was in black-and-white, I did not worry about color balance. To get excellent color on critical transparencies in mixed-light locations, professionals formerly had to overpower the existing lighting with strobe, or use a professional Color Temperature Meter and put color-compensating filters over lenses and/or colored gels over lights to correct color for tungsten or daylight films. Today's easier alternatives are to scan film to computer and correct the color with the Photoshop program. Have Kodak or a service bureau make scans for you, or you can scan them yourself with a film scanner or shoot digitally. With good digital cameras, you can custom set the White Balance mode to compensate for mixed-light sources (see camera manuals).

the little screen level as you view, or you may not spot exposure problems, like lighting that is over-contrasty.

Use manual camera and lens settings and an incident-light flashmeter to read and refine digital exposures made under strobes or professional flashes.

Approach

Since you must light a fairly large area, this assignment is most easily done with strobe lights. I often use one 500 WS strobe pack with two light heads or three spaced-out 300 WS monobloc strobe units. The assignment could also be done with several powerful, spaced-out, battery-powered manual flashes—tiny flashes won't do. Each strobe or flash should be equipped with a slave. Triggering the slaved flashes or strobes from the camera eliminates the use of synch/pc cords and "jumper cables"

(which physically connect several strobes to each other for simultaneous firing).

Quartz or floodlights will work fine for this assignment, too; with those I suggest using fast film. You will need at least two 500 or 600 watt lamps. With hotlights, be especially careful not to overload electric circuits.

In public places, weight the bottom of all light stands and tape down all cords.

Set up and then carefully space out and meter your lights. Be sure that light on the whole scene is even and that there are no "hot spots" or "black holes." Do this before inviting your models onto the set, so that they won't get stiff. While you are arranging your lights, have your models sit at a table or on a couch in a formal living room, hotel or restaurant, or at a desk or table in an office, school, hospital, or wherever you happen to be shooting.

This shot can be approached with the aim of flattering the subjects, for personal artistic aims, or for intended publication. "Working portraits" and "illustrations" are posed, but are meant to look unposed—you can see them in many corporate brochures, advertise-ments, and magazine images. With this type of shot, try to capture animated expressions, gestures, and off-guard moments, so that your models look as if they are working and talking, not just posing stiffly.

With either approach, the whole scene should look natural—as though soft light has lit the scene from nearby windows.

To achieve this effect, aim lights at your subjects through one or more umbrellas or perhaps a soft box, while lighting additional space by bouncing light off a white wall or ceiling. If a white or light-hued wall or ceiling isn't available, add a large, white reflective surface. Bring in a big white or silver collapsible reflector or a Fome-Cor panel or two, or gaffer-tape up a white sheet or a silvery Mylar space blanket.

If there is no need to "stop" fast subject movement, in large rooms, I set my camera on a tripod and use a slow shutter speed, usually 1/30 of a second, with my strobes or with hotlights. This slow shutter speed allows some available room lighting to enhance strobe or flash pictures, burning in any existing room lights and making the whole scene look natural.

Self-Assignment 6: Copying Art

Use two lights and two reflectors to make accurate color copies of paintings or other flat artworks, photographs, or documents. If the art is under glass, you should work in a room that can be completely darkened, or work at night.

Essentials: Appropriate color film for your tungsten or daylight-balanced light source, or appropriate mode setting on your digital camera (see Lighting and Color Balance on pages 27–29). Two lights and two to four light stands. Two sheets of white artists' illustration board for small works. Big reflectors for big artworks: use 4 × 8 foot sheets of stiff white Fome-Cor (from lighting dealers) or two white bedsheets.

Also: A hammer, two to four "A" clamps, a roll of gaffer tape, steel picture hangers, clear-headed pushpins, clear nylon fishing line, white artists' tape, clear Magic Tape, and a color separation guide (see page 41).

Set up paintings on an artists' easel against a black or clean white background. A sheet of hardboard or plywood larger than the artwork is handy for hanging heavy paintings. Mine is covered by black felt, but black paper will do fine. The easel will lean back slightly. Mount your camera on a tripod and make sure it tilts to the same angle as the painting.

Approach

I shot a lot of art years ago, when I traveled to various museums photographing and copying famous works for a textbook company. Paintings to be photographed can be hung on a wall (some museums don't allow art to be touched)

Painting by Caroline Nye, copied with two photofloods.

or, if movable, hung from a backboard placed on an easel. Sculpture, china, and other three-dimensionals are stood on a table, while books are laid flat with the pages held down with clear fishing line.

Darken the space, and aim and angle two white reflectors at about 45 degrees, about three feet from either side of the art. With a built-in or handheld meter, make sure the art is evenly illuminated (more of a problem with large works than with small ones—if the art is huge, you may need four lights, not two).

This painting was copied using two 500 watt photoflood lamps in ten-inch Smith-Victor reflectors, but I could have used two quartz lights, two monobloc strobes, two strobe heads, or even two adjustable flashes to do the same thing. I carefully metered at the four corners plus the center of the painting, moving lights slightly until exposure was even. Of course, both lights must be of equal power, equally spaced, and aimed at reflectors angled at equal distances from the painting. (A huge painting might call for four lights.) Here, exposure was 1/60 at f/8 with my digital camera set to ISO 400; the exposure would vary if different light sources were used. With hotlights it's easy to spot undesirable reflections. If you shoot digitally, preview results on the camera's LCD screen or, better yet, on a computer screen. If making critical copies on film with strobe or flash, you may need to make tests with a professional Polaroid camera and film.

For sculpture, the aim, of course, is to bring out form and texture.

Aim your lights at reflectors, so that the lights bounce back and illuminate the work, but do not leave shiny areas or hot spots. With the camera on a tripod and carefully centered, study the work through the lens, and make sure that absolutely nothing reflects. If the surface of the art is highly reflective or behind glass, you may have to wear black clothing and gloves and cover a shiny tripod with black tape to avoid becoming a reflection yourself.

I bracket (vary) all art exposures, with 1/3 or 1/2 f-stops over and under "normal," as read by an in-camera meter off a gray card.

Since viewfinders don't always show the exact area photographed, I leave a small margin around the edge of paintings.

Most professional art copyists who shoot for reproduction use a 4 × 5 inch camera and color transparency sheet film and choose a black background. Carefully made 35mm color slides are fine for showing to art galleries. Black-and-white works can be copied onto black-and-white film, of course. Color negative film is not often used to copy art, but will do fine for display on the Internet. Set a digital camera's white balance to match the light source you are using. If the color transparencies or digital images you make are to be used

Wooden sculpture by Ann Pachner. Two variations plus lighting setup. To emphasize the texture, I lit the foot-high piece from the side with one 500 watt flood lamp in a ten-inch reflector. A collapsible silver fabric reflector placed opposite the main light filled in (lightened) the shadows. I moved the main light around to achieve two somewhat different effects.

for professional color reproduction, include a Kodak Color Separation Guide or Gray Scale or a GretagMacbeth Color Checker (all are sold by professional photo dealers) in the photo frame of each painting or near other artwork copied. Sometimes, a ruler is also included in copies of small works.

Self-Assignment 7: Reflective Objects and Glass

This assignment is most easily done with strobe lights. Set the highest possible synch speed on your camera to eliminate unwanted available-light reflections. Try photographing a large pocket watch, a silver teapot, flatware, or glass. Try to show all important details, such as each number on the watch or designs on teapots or glassware, while avoiding burned-out hot spots and ugly reflections from the surroundings. If you use hotlights, work in a totally darkened room or at night to avoid unwanted reflections.

Approach

This can be a tough assignment! "Tenting" is a way of surrounding your subject with translucent white cloth or plastic. "Tents" are made commercially and sold by professional photo dealers. If you are handy—photographers need to be—try making one yourself from "Tough Lux" or "Roscolux," two brands

The silver teapot (*right*) was highly reflective. I surrounded it with a homemade tent of white paper, aimed my strobe from outside, and poked my 20mm lens through the small hole. The lens reflected on the silver as a small dark circle, but that was easily retouched. Digital exposure at ISO 400 was ⅟₆₀ at f/8.

of translucent sheeting available from photo and lighting dealers. Cut and staple the plastic to a suitable size and shape to enclose your subject, and cut a slit or hole just big enough for your lens. Work with the camera on a tripod, poking the lens through the hole while aiming a light or lights from outside the tent. This should eliminate all or almost all unwanted reflections. Small bits of carefully placed black or white card may be needed inside the tent to cast a few reflections and avoid too bland a look.

Another approach is to work in a totally darkened room and have black behind or around the shiny object. Aim a light from one side with a reflector opposite. This works well with glass. You may have to wear black clothes and even gloves to prevent unwanted reflections.

Glass can also be placed on a glass shelf covered with Roscolux or Tough Lux translucent sheeting and lit from below and behind. Translucent still-life tables that take 4×8 foot sheets of plastic are used by professionals.

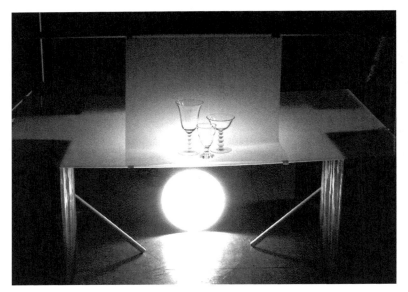

Lighting glassware—or any transparent or translucent object—from behind or below reveals maximum detail possible and is pretty, besides. I use a piece of quarter-inch frosted plastic for this purpose. Here it was propped on four studio "apple boxes"—sturdy boxes people can stand on. A sheet of Roscolux diffusing gel was taped over the plastic table. I placed one 500 watt photoflood in a ten-inch Smith-Victor metal reflector on the floor, angled so it illuminated the glasses from behind and below. I made the shot with my Fuji S-1 digital camera set to ISO 400 in a darkened studio to eliminate unwanted reflections. Exposure was 1/30 at f/8 on the glasses. It was impossible to show detail in both the darkest and brightest areas of the setup shot (the contrast was too great), so I exposed for the dark areas and let the highlight overexpose.

ABOVE: The state quarters in close-up were lit with two 300 WS monobloc strobes aimed from the side through a homemade tent made from two sheets of Roscolux gel taped together. Exposure was 1/125 at f/16, with my digital camera set to ISO 400. I used a 105mm manual macro-Nikkor lens aimed straight down.

RIGHT: Some close-ups require one light shone through a "tent," and some require two. See page 112.

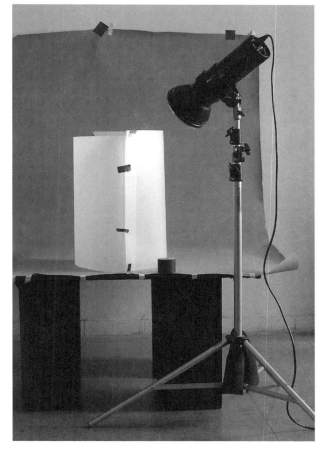

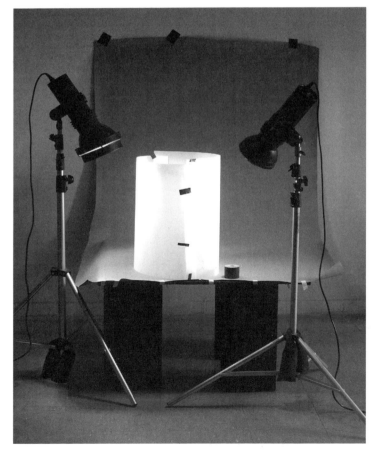

In order to show all the details on the watch and control unwanted reflections, two mono-bloc strobes were aimed into a "tent" of frosted plastic sheeting (this can be purchased from photo dealers). I bracketed the ISO 400 digital exposures. Basic exposure was 1/60 at f/16.

Self-Assignment 8: An Informal Party or Formal Event

Good posed and unposed party shots are needed for both personal and professional reasons. Everyone likes party pictures.

Big money is often spent on kids' christenings and birthday parties, bar and bat mitzvahs, anniversaries, family reunions, "sweet sixteen" and "quince año" celebrations, and weddings. The organizers and participants, of course, want a photographic record of the event.

School functions and corporate awards ceremonies and meetings are other possible subjects. For this type of assignment, the way you interact with people is just about as important as how you set up your lights.

If you can shoot parties well, you have a good chance of earning decent money, either by selling prints to individuals or by charging a fee for the shoot, or both. I started my professional career by shooting public-relations pictures for the British Tourist Authority; I took pictures of visiting Brits making promotional appearances. The shots

The hard light of direct flash suits the quality of this Halloween portrait. ISO 100 film, 28–80mm lens, 120 GN TTL flash, exposed at ¹⁄₆₀ at f/11.

were pasted in albums and also distributed free to the travel sections of newspapers and magazines.

Ask event or party organizers if they want black-and-white or color prints. If

If you shoot from a close distance, a TTL flash will render different skin tones quite accurately. As usual, I used a rather slow shutter speed to take advantage of as much existing light as possible. As the client wanted prints, I used Kodak Portra VC, an ISO 160 film. Exposure was ¹⁄₃₀ at f/8, with TTL flash.

Times Square Bride and Groom. On a New Year's Eve, I spotted the newlyweds in their limo and ran backwards down Broadway to get this slow synch flash shot. My camera was loaded with ISO 100 film and manually preset, to record some of the existing lights, at 1/15 at f/4. My Nikon SC-24 flash was preset to TTL mode. I made just five images—this one is my favorite. Because the subjects were semi-silhouetted against bright lights, the flash "froze" them without a blur.

they want or need you to shoot digitally, ask if pictures are for the Web, eventual printing, or both, and how the images are to be delivered.

If shooting commercially, make sure you understand what is wanted. Get requirements in writing if possible. Don't shoot a big-money wedding or other big event without a contract. Wedding and other contract forms are included in *Business and Legal Forms for Photographers*, by my publisher, arts lawyer Tad Crawford. (See back page of this book.)

Equipment: Convenient, fast-acting, battery-powered flash is the light par excellence for parties. Always carry a good number of spare batteries. If you own a detachable flash, mount it on a bracket, and use a bounce card or dome over the flash head to reduce the possibility of the dread redeye effect.

I mostly use a moderate wide-angle 35–70mm zoom lens to shoot events, and I carry a 20mm wide-angle lens for big group shots. I carry a telephoto lens, too, to get close-ups and shots of speakers on a platform.

Remember, if you are shooting with a digital camera, your lens focal length is increased by about 50 percent. A digital camera's 35mm lens is equivalent to a 50mm lens on a film camera, for instance, so adjust your lens arsenal accordingly.

Special Circumstances

Photographing big events is a big responsibility that calls for experience. You must work fast, often keeping track of names and finding and posing certain group shots on occasion. Sometimes you will need to set up strobe lights for formal, posed shots. If you are

Posed groups can be formal or informal, depending on the subjects. I had fun with the comedy group, the Jolly Llamas. A strobe bounced out of an umbrella and an exposure of 1/60 at f/11 were used.

I shot this group of Australian women World War II vets in Sydney on the fiftieth anniversary of victory in the Pacific. My on-camera TTL flash "filled" eye sockets and gave a little sparkle to the outdoor scene shot in shade. Exposure was 1/250 at f/8 on ISO 100 film.

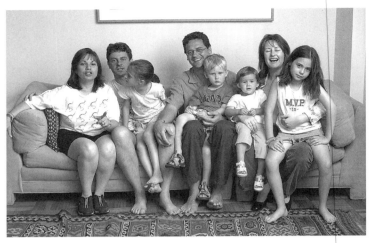

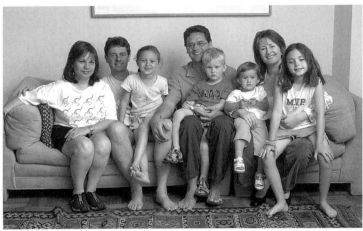

TOP: This family portrait shoot was lit with a 500 WS Dyna-Lite strobe with two heads bounced out of thirty-six-inch umbrellas evenly spaced about four feet in front of and six feet above the subjects. The aim was to make the room look as though it were daylit, not to do anything fancy. With this type of shot, lighting is not the major problem. Getting everyone to concentrate on the camera and look good all at the same time is. This picture has a certain charm, but the girl at left has turned away, and the woman at right is blinking. The girl at right looks very pretty. BOTTOM: This was best shot for seven out of the eight people, but notice that the girl on the right is not looking at the camera.

offered money to do a big job by someone who likes your style, and you want to do it but are scared of the technical aspects, do it, but hire an assistant. There are specialist lighting assistants for hire in big cities; inquire with assistant associations, or ask photo schools and other photographers for recommendations. If necessary, rent a strobe or two also.

Group Shots

I always set my camera on a tripod to compose formal group shots.

I often mount my flash on a bracket to minimize the possibility of "redeye"— red reflections off the retinas of eyes. Sometimes I use flash off-camera, connected by an appropriate cord, and hold the light high, but carefully aimed slightly down on the group. This mini-

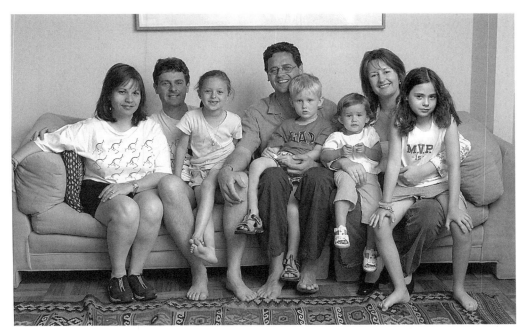

The final version, with the pretty head of the girl pasted in (using the Photoshop program) and tilted slightly. Now, everyone is looking at the camera, and no one is blinking. My Fuji S-1 digital camera was set at ISO 400, with a 28–800mm zoom lens set at 28mm; exposure was ⅟₆₀ at f/9.5 (an intermediate setting available on electronic cameras).

mizes redeye problems and unwanted background shadows, too.

To minimize hot spots on glasses, ask people who wear them to turn their heads slightly up, down, or sideways while continuing to look at the lens.

With the camera on a tripod and your eye at the viewfinder, ask everyone in the group to look into the lens. Shoot the instant you see this happen. There's always someone who blinks a lot in any group, so make several shots to be sure you have at least a few where everyone has wide-open eyes.

Controlling a big group's attention for more than a minute or two is often a problem. One wiseacre makes faces, and shy or bored people look away or talk most of the time. Jolly everyone along collectively and individually with plenty of chat.

For business groups, find out in advance exactly what is required. Be aware of rank in corporate groupings' shots. Top guys and gals must be placed up front, or higher than the rest, or both! If you are photographing any kind of awards ceremony, be sure the trophy, plaque, or big check features prominently in the pictures. You may need to ask that this item be held in an angled fashion, to face slightly up or down while you shoot in order to minimize reflections.

For weddings, I like to first pose the bride and groom alone, then with parents, bridesmaids, ushers, and so forth. Finally, pose everyone together.

Approaches for Shooting Parties

Parties are fun for guests, but hard work to shoot.

Rule 1 is always to carry plenty of film and batteries. Rule 2 is to work close.

For business, charitable, and public relations events, carefully place people according to rank, with the most important front and center, and be sure to prominently feature any plaques, checks, awards, or trophies given out. I used a TTL flash mounted high on a bracket, connected to the camera with a TTL cord, and a LumiQuest device on the flash to minimize "redeye" problems. I asked them to tilt the big check slightly down to avoid a hotspot I noticed from the flash. ISO 400 digital exposure was ⅓₀ at f/8.

Rule 3 is to talk to people while you photograph them, so they'll look animated in the picture.

Rule 4 is to remember that many people prefer not to be photographed with drinks or cigarettes—this is invariably true at business and corporate events.

I still shoot parties occasionally, usually for close friends as a gift. I now work with a handheld TTL camera and TTL flash mounted on a bracket, connected by a TTL cord. I use a 28mm lens and a 35–80mm zoom with ISO 400 color print film or the ISO 400 setting if shooting with my digital camera. My aperture is always f/5.6, and in a big space, I vary shutter speeds (using ⅓₀ most often) to record as much background light as possible. My flash is powered by a pair of cigarette pack–size six-volt Underdog battery packs—they attach under the camera, and each gives me about 150 full-power shots with a 1.5-second recycle time (300 or more images is plenty for most events).

With flash, I work within about ten feet of most subjects, usually softening the light with a StoFen dome or LumiQuest bounce device over the flash head. Both devices reduce flash output by two f-stops and reduce maximum flash range, so I aim flash direct if I must shoot from some distance. The closer I work, the better my flash shots look. Working close minimizes yawning black backgrounds and high-contrast problems. I try to get people to talk to each other and not just stand staring into the lens.

Self-Assignment 9: A Picture Story

Picture stories are the mainstay of classic photojournalists and are often, though not always, about people doing or experiencing something. A good picture story should always appear natural—purists say situations should never be posed. However, waiting for something to happen can take a long time, so in my opinion, it's okay to recreate something that has actually happened, as long as you explain this in the captions.

A "photojournalistic" natural, apparently unposed style has recently become quite popular with wedding photographers and is even catching on in some advertising campaigns. In these cases, I can see no harm whatever in "setting up" or posing shots.

Any subject you have easy access to is an okay place to start shooting stories. A series documenting a baby's first efforts to walk, culminating in his triumph, is as valid, and probably as publishable, as a story about the training of a doctor, life on an oil rig, or a new immigrant's settling into an American community.

THIS PAGE AND FOLLOWING: I chose to shoot a cake-frosting session. I wanted even, shadowless lighting to allow for subject movement, and so used a Dyna-Lite 500 WS strobe with two heads in the 8 × 12 foot space. One head, at 250 WS, was clamped to a shelf out of camera view at kitchen left and aimed at the left white wall, so it reflected soft light on the opposite white wall behind the cooks. The other head was cut to half power, 125 WS, and aimed through a 3 × 4 foot black-backed soft box at the table from about 3 feet from camera right. When metered, exposure all over the area I was photographing was 1/60 at f/11, or very close to it.

Some picture stories can be shot in an hour or so, while others may take days, weeks, or months; some subjects have become a lifetime's obsession for certain photographers. Look for the contemporary pictures of the world's workers by Sabastião Salgado—one of my greatest heroes as a photographer—and the classic stories of W. Eugene Smith. There are many books in print about both of their work and about other great photojournalists.

View photojournalism, too, in old and new magazines. Travel stories can always be seen in *National Geographic*, and news stories in *Time*, *Newsweek*, and other U.S. and foreign magazines. Some national and local newspapers run serious picture stories, too. So do school papers, business and public relations newsletters, textbook companies, and more.

When you shoot a story series, think about the content first, of course. Then

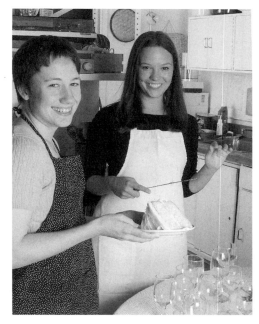

think how the images might be laid out in a magazine or newspaper. Shoot verticals as well as horizontals, close-ups as well as wide-angle and middle-distance compositions. If you find an unusual or universally appealing subject, can catch real emotion and mood, and have a distinct beginning, middle, and end to the piece, try submitting it for publication.

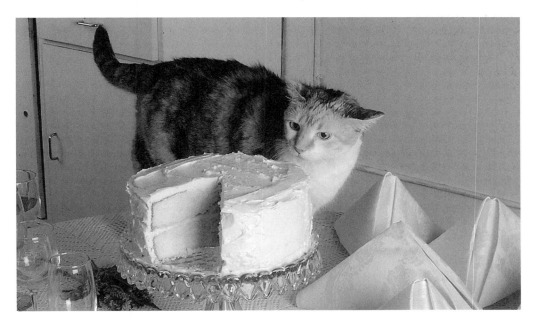

Approaches
to Popular
Subjects

The Approaches

I have chosen the selected subjects because they are often difficult to photograph well without added light, are always in demand, or because (especially in the case of nature and landscape photography) they are a favorite subject for those who photograph for relaxation. In these pages, you will find approaches to the following themes: action pictures, actors, babies and children, business, architecture and interiors, landscape, illustration, and nature. When you have finished working through the self-assignments, try your lighting skills on these new techniques.

As I have said earlier, nothing will improve your photographic and lighting skills more rapidly than plenty of practice. Shoot with lights as often as you can. You will probably learn quite early that one kind of subject matter appeals to you more than others. This may eventually influence you to specialize in one area of personal, fine art, or commercial photography as you become experienced or professionally established.

Emerging professionals—and indeed anyone who is asked to shoot a type of subject not tackled before—should find these pages especially useful.

Caution: If you are being paid or if someone is counting on your pictures, you have a responsibility. Before shooting any important or paid job, I strongly suggest that you make a trial run or schedule a "test shoot" of a subject approximating the assignment. Use whatever lighting technique I suggest for the subject, adapting the technique, if needed, to your specific requirements and equipment. If there is time, first do the test as I suggest it, then add your own creative variations—you may find a better lighting solution than mine. Nothing in lighting or photography is written in stone, and there is no one perfect, unchangeable rule that cannot be bent or broken.

Lighting from low and to one side always emphasizes texture, whether a hotlight, flash, or strobe is used.

Approaches to Lighting Action Pictures

If you work close, say within ten feet of a subject, a flash will "freeze" a fast-moving subject well. The more the flash power is reduced, the shorter the flash duration and the faster the motion that can be stopped. In general, strobe is the most useful lighting for stopping or freezing action, but note that the inverse square of light falloff applies to strobe as well as flash, and you cannot light, say, huge stadiums with one strobe. The specialists who shoot NBA games set up several channeled, slaved strobes above the court to get those cleanly lit action shots.

Multitalented actor, gymnast, and mime Sal Brienik did his thing in my studio, which is not huge. I lit him with one 2,400 WS strobe with power pack set to half power (1,200 WS). The strobe head was bounced out of a forty-five-inch black-backed white umbrella angled over the set on a boom arm about ten feet in front of and aimed down onto Sal. Digital exposure at ISO 400 was 1/125 at f/13.5. In my space, I could not get a clean, white background large enough for all his leaps, so I assembled the images using Adobe's Photoshop 7 program and its Extract filter. In the old days, the composite would have required professional retouching—the computer work took me an hour.

Approaches to Lighting Actors

Use any controllable lighting. "Head shots" are almost always black-and-white and almost always are verticals. Aim for even lighting without any heavy shadows, and separate the head from the background—a casting director or agent looking at a picture needs to know exactly what the actor looks like. Generally choose a plain or very simple background so as not to distract from the head. Obviously, you try to depict the actor as attractive and energetic as possible.

Character actor Michael Moran is often seen on television and the New York stage. He wanted some shots to emphasize that he plays white-collar as well as blue-collar roles. I used one 500 watt photoflood as the main light and a 250 watt photoflood as fill. This shoot was done on a digital camera set at ISO 400; exposures were in the region of 1/60 at f/8.

Approaches to Lighting Architecture and Interiors

Carry the widest-angle lenses you own, plus a tripod to keep vertical and horizontal lines level. Make several vertical overlapping shots to record a panoramic view of a whole scene—there are computer programs that can "stitch" these together. If you work with existing daylight or indoor lighting and add one, two, or more small, slaved flashes to lighten dark corners, you can get excellent effects without carrying a huge amount of strobe equipment.

This soft goods shot was made for a catalog. The bedspread, cushions, and tablecloth had to be lit evenly, and the indoor and outdoor lighting had to be in balance, so that the window was neither burned out nor dark. First I took an outdoor reading: It was ¹⁄₂₅ at f/11 on ISO 100 film, so that was the setting I aimed for in lighting the interior. Indoors, I used two 1,200 WS strobes shone through four umbrellas, aimed around the room, which was about 12 × 15 feet in size. I moved the strobes around, metered, added diffusing material over some of the umbrellas, and metered again, until everything was in balance. This took quite some time to achieve.

I metered for the windows in this unlit chapel in a big French church and added light from a detachable TTL flash aimed direct. Exposure on ISO 50 film was ¹⁄₂₅₀ at f/5.6.

A catalog shot made with a 1,000 WS strobe aimed through a fabric softbox, from slightly above and left of the cushion, about four feet away. Exposure by meter was not recorded.

TOP: View of the New Jersey State Capitol, Trenton. Fuji S-1 digital camera at ISO 400, 20mm lens, exposure manually set at 1/30 at f/5.6.

BOTTOM: The New Jersey State Capitol, Trenton. Same exposure as above, but with the TTL-controlled pop-up flash activated. Although I made and played back several test shots and bracketed final exposures by varying the f-stop, the contrast between the dark interior and the white dome was too great to record detail in both, so I let the dome highlights "blow out" a little. If I had been on assignment, I would have lit the rotunda with a powerful flash or a portable strobe. I could then have chosen a smaller f-stop or a faster shutter speed (or both) and brought the light in both areas into balance. (On assignment, I would also have carried my 14mm lens—a 20mm lens becomes effectively a 28mm lens on a digital camera, the reason I was not able to include the whole dome in these shots.)

Auxiliary slaved flashes can improve pictures of interiors lit by flash or strobe. A shot made with a 120 GN TTL flash on-camera left the top of the stairs dark (*left*), even though windows lit the area. I placed two Morris Mini Slave Wide Plus flashes with built-in slaves upstairs, one in the flowerpot, one on a bookshelf. A third placed inside a first-floor door lightened the lower hallway. These small flashes have a GN of about 30, so they cannot overpower the main flash or strobes. Exposure was 1/30 at f/8, with an ISO 400 setting on a digital camera.

Approaches to Lighting Babies and Children

Use any lighting you have. I like light, bright, "high-key" lighting effects for kids and ask parents to dress them in light colors, so the face is the key element in the picture. Expose with care, ideally metering off a gray card. Overexposed digital images can be impossible to print. I ask parents when the child is at his best and to bring him at that time—even then, you may get only a few minutes to shoot. Having a bubble blower handy is almost guaranteed to produce smiles.

To use flash fill on close-by shaded or backlit subjects in bright sunlight, expose for the brightest part of the scene and add flash. This proud grad and her daughter were shot on ISO 100 film at ½₀ at f/11; a flash used in TTL mode was on-camera. Use automatic and small manual flashes in this way, too, if you wish. If you set a small f-stop and work at about five or six feet from the subject, a small flash cannot overpower the sunlight.

Fill flash brightened this charming group on an overcast day in Washington. I used the camera meter in matrix mode (I almost always do) and manually set shutter speed and f-stop for slight underexposure of the background. I used ISO 100 film at ½₅₀ at f/5.6. I added fill light from my on-camera 120 GN adjustable TTL flash aimed through a Sto-Fen dome.

ABOVE: A 500 WS strobe used bare-bulb without any metal reflector was placed about ten inches behind the girl's head, so it could not be seen from camera position. I hung a 20 × 30 inch sheet of white cardboard, with a hole cut for my lens, about three feet in front of the model to reflect light back into her face. I used an incident-light meter, positioned at her face and aimed at the camera, to determine exposure. I knew by experience that the backlit hair would be brightly highlighted and that every strand would show. I used a Nikon FM-2 mechanical camera, ISO 100 film, and an 80–200mm f/2.8 zoom lens. Exposures were bracketed in half-stops; best exposure was ⅟₆₀ at f/8.

OPPOSITE: A small adjustable flash can be used to mimic strobe lighting. (For more on this technique, see page 72.) For this portrait, an off-camera TTL flash used in TTL mode was mounted on a stand with the head reversed. A TTL cord connected the camera and flash. A twenty-four-foot silver umbrella taped over the flash head bounced soft light down onto the subject. With ISO 100 film and an 80mm lens, exposure was ⅟₆₀ at f/5.6.

A high-key portrait of baby Davie, lit by two 300 WS strobes. With my digital camera set to ISO 400, exposure was 1/125 at f/11. *Note:* High-key lighting requires precise exposure. I made this shot while still learning how to shoot digitally. I found out the hard way that if you overexpose high-key images, you cannot print all the detail in the highlights. If you underexpose slightly, you can easily lighten the image if needed. With film, especially slide film, you should always bracket your high-key exposures.

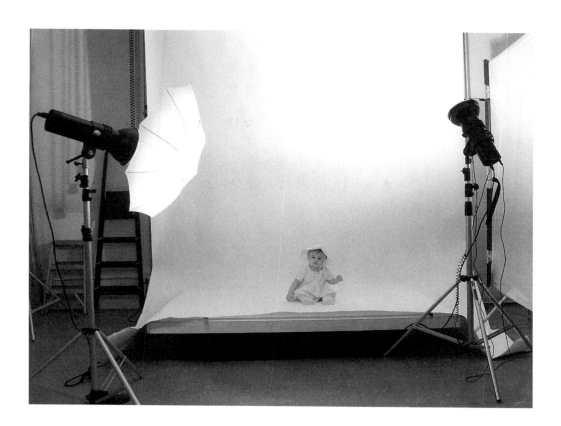

ABOVE: I often use this high-key lighting setup with two 300 WS monobloc strobes. The main light, diffused by a white umbrella, is aimed at the subject, and the fill light is bounced off my white ceiling. In order to avoid uneven light and overexposure, it is critical to use an incident-light meter aimed at the camera from different areas of such a setup. Precise exposure will vary according to your setup.

RIGHT: This shot was made in the studio with a 300 WS monobloc strobe aimed through a 3 × 4 foot soft light box about four feet from the subject at camera left. Exposure was 1/250 at f/22.

Approaches to Lighting Business Executives

Most business portraits and group shots are quite formal. Rank is important, and top executives should be front and center.

Occasionally, a casual look is desired. Inquire at the time of the shoot. If possible, I take an assistant, almost always work with strobes, and always arrive early to set up lights and scout locations. To record computer screens requires a long exposure combined with strobe lighting—be sure to carry your tripod.

A two-light portrait using a 500 WS strobe with two heads. One head provided backlight, from off set at camera left, onto the mid-gray background placed about four feet behind the subject. The edge of the background light was softened with feathered aluminum foil taped around the edge of the reflector. The main light was aimed from the high three-quarter position from camera right, through a 24 × 36 inch black-backed, white fabric soft box. It was about four feet in front of the subject. Exposure by incident-light meter on ISO 100 film was 1⁄60 at f/11. I made test shots and bracketed exposures by varying the f-stop.

Skin tones are critical for portraits, also for fashion and beauty images. If you include a Kodak 18 percent gray card in a film or digital test image, it will help you judge exposure and, more subtly, help you decide how to expose for desired skin tones. It is a widely used convention that skin from fair to dark be reproduced slightly lighter than nature intended. This minimizes any minor blemishes and usually looks nice, too. See fashion and beauty magazines. The lighting used here was the three-strobe setup shown in the picture on page 141.

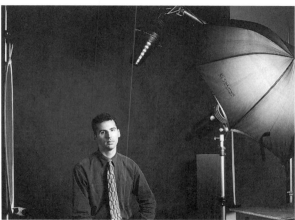

ABOVE: Portrait of Michael made with a strobe with two heads plus a silver reflector.

LEFT: A 2,400 WS strobe was used at half power. The main light was one head bounced out of a black-backed umbrella from a high three-quarter position down onto the subject. The second strobe head, fitted with a snoot and hung from a boom, was used to light the subject's black hair, giving it texture and shine and separating it from the black background.

Two approaches to a portrait. The first picture of Darren (*left*) was lit with two 300 WS monobloc strobe units, both turned down to one-quarter power. The background light, diffused by a sheet of fiberglass, was aimed from the left onto mid-toned, no-seam paper about four feet behind the subject. For the main light the strobe head was fitted with a 5 degree grid and aimed from about three feet to the right and down onto the subject. This was to isolate the head for a strong effect. The second picture (*right*), made without a grid, is a typical business-type image that has moderate contrast and would reproduce well in newspapers and newsletters, where dark pictures tend to block up. The second portrait was lit with the main light plus grid alone. No camera settings were changed. Obviously, this is the handsomer of the two images; the higher contrast could be printed for a portrait client, as well as reproduced successfully in magazines and books using quality paper. I shot digitally at ISO 400. Exposure for both pictures was the same—1/60 at f/16.

The home office. This shot was made with flash at below-synch shutter speed; I especially wanted to record the image on the computer screen. With my digital camera set to ISO 400 at 1/30 at f/5.6, I rotated the head of my TTL flash, so it bounced off the white wall behind me down onto the subjects.

Approaches to Lighting Set-Up Situations for Illustration

Illustration, or setting up and lighting a believable situation or scene, is one of the most difficult tests of lighting and photographic skill. It requires patience and often testing with a Polaroid camera and film, or a digital camera, to ensure you get desired results. Try setting a scene of a couple playing chess, or eating in a restaurant with or without a waiter or waitress present. Think about the look of light in a room or in the restaurant. Then think about suitable furnishings, room or table decorations, the background, and, of course, about your subjects' clothing. When you have done all those things, you must then direct your models so that they will act convincingly.

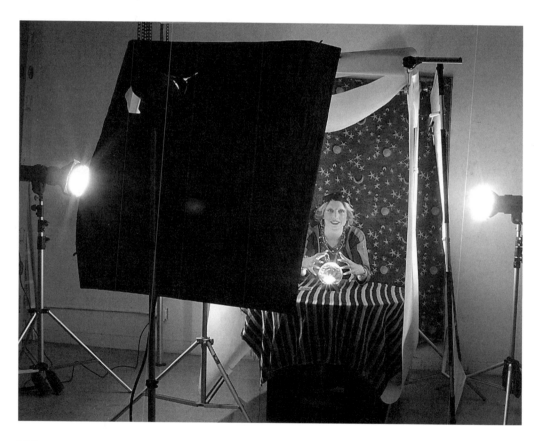

This setup shows how the picture of the fortune teller on page 78 was lit with three strobes plus a Morris Mini Lite. Two 300 WS monoblocs were aimed from either side about three feet from the subject; both were diffused with fiberglass sheets and further diffused by being shone through a tent of translucent paper—all this to control reflections on the crystal ball. One Dyna-Lite strobe, used at half power (250 WS), was aimed from the front with the head diffused by a 36 × 48 inch black-backed soft box. A tiny self-slaved Morris Mini Lite, placed behind the crystal ball, was set off by the strobes. The image was not retouched or manipulated—the glowing ball effect was achieved by lighting alone.

These illustrations were shot on a studio set with a 36 × 48 inch window fitted with panes of eighth-inch-thick white plastic sheeting instead of glass. Lighting was two 1,000 WS strobe packs and four strobe heads. The main light came from two heads placed one above the other two feet behind the window at left. The fill light was provided by two strobe heads bounced off a 4 × 8 foot panel made of two braced sheets of Fome-Cor, off camera at right, about eight feet from the subjects. Exposure with an incident-light meter was ¹⁄₆₀ at f/11 on ISO 100 film. I made test shots with a Polaroid camera and film, and final exposures were bracketed by varying the f-stop. I think the first picture just "worked" a little better than the second.

Approaches to Lighting Landscapes and Nature

Any small flash can be an effective adjunct to landscape photography, anywhere. Expose for backgrounds, and add flash to lighten close shadows or emphasize foregrounds. Be aware that the flash will not light anything much beyond ten feet, unless you use the widest possible lens apertures—and those will reduce your depth of field (zone of sharp focus) considerably.

Approaches to Lighting Nature

A few great masters of nature photography, like Stephen Dalton (author of many books), set up special lighting in a studio to record the movements of tiny creatures. Most nature photography is done outdoors, though, and even a tiny flash can cast a gleam into an animal's eye or stop the movement of a bee on a flower. Close-up specialists often work with two joined TTL flashes on a double bracket or with a ring flash. Rather than using Autofocus, which I normally rely on, I manually focus for extreme close-ups, sometimes rocking back and forth during multiple shots to get just the point of sharp focus I want. Macro lenses, extension tubes, and close-focusing rails are available for most camera systems.

An example of how flash can help landscape photographs. On an overcast April day in Washington, D.C., with my digital camera set at ISO 400, and with an adjustable on-camera flash, I exposed for the background and added TTL flash. Exposure was 1/125 (maximum flash synch speed for that camera) and f/8.

Brittany sunset with rocks, birds, and boats. Flash can be helpful when added to backlit landscapes and seascapes. For this shot, with the handheld camera in manual mode, I set an exposure of ⅟₆₀ at f/5.6 with ISO 50 film, based on a meter reading off the orange sky, but not off the setting sun itself (that would have underexposed the water and sky). Then, I added flash set to TTL mode—that lit the silhouetted foreground rocks. You can clearly see the flash fall off here, but I do not find it objectionable.

Flash close-up of Queen Anne's Lace and ant. With ISO 50 film, a 55mm macro lens, and my handheld camera in manual mode, I shot this image while aiming a Nikon SB-23 flash from out of frame, camera left. This TTL but nonadjustable flash was connected to the camera by a TTL cord. Exposure was ½50 at f/16. *Note:* Autofocus lens mode does not work well for extreme close-ups; instead, I focus close by hand, then rock back and forth as I shoot to fine-tune the focus.

I made this picture in southern New Jersey with the help of a slaved Vivitar 283 flash on a pole near a place where frogs congregate. I was inside a tent. The flash was triggered from the camera with a Wein infrared transmitter. The exposure of ½50 at f/8 on ISO 50 film was chosen so that the flash would fill dark shadows. If a frog came too near the flash, he was overexposed. It took me a number of bad shots to get this good one.

Two flash pictures made through glass. In general, don't casually shoot flash pictures through glass from a distance, or reflections will probably spoil the shot. If you take some care, this can be avoided. I shot the stuffed jaguars at the New Jersey State Museum in Trenton by placing my 20mm lens fitted with a rubber shade placed flat against the glass case. The adjustable on-camera flash was aimed through the glass. Exposure was in TTL program mode.

The rare Australian quoll was photographed in a nocturnal exhibit at Healesville wildlife sanctuary near Melbourne. With permission, I set up an adjustable TTL flash on a light stand and my camera on a tripod. Flash and camera were connected with a TTL cord. I observed the animal's movement patterns, then aimed the camera and direct flash carefully. I made a few test pops to make sure that no white hotspots hit the glass near where I planned to catch the fast-moving beast. To eliminate reflections of people walking by in the dim existing light, I exposed at the highest possible shutter speed that synched with flash—1/250. With ISO 100 film, the required lens aperture was f/8.

Another shot lit with two 300 WS strobes. One was aimed at the ceiling; the other, diffused by a shoot-through umbrella, was aimed from slightly behind and down onto the subject. Exposure on my digital camera set to ISO 400 was by flashmeter, but was not recorded.

Wrap-Up

Showing Your Work

Your work as a photographer isn't complete until you have edited and shown it to others. Select only your best images to present to family and friends, to fulfill business- or school-related assignments, or to post onto a personal Web site. Many minilabs now make good thermal prints from digital originals, and slides, too, at moderate prices.

Professional Print Portfolios

If you shoot film, of course, edit, proof, and make prints from negatives in a traditional darkroom, or have a lab do it. A professional "book" (portfolio) to show potential commercial or fine-art clients should show the kind of work you want to do and should be technically excellent, entertaining to the viewer, and not too long—fifteen to twenty images is considered to be a good number for a portfolio.

Today, a book can be made up of traditional or top-quality digital prints. Most professional photographers, including myself, now show excellent digital prints. These can be from originals shot on film and then scanned to computer, either by a lab or with a film scanner, or be digital originals. Ideally, originals should be made with a camera that can record at least a 3 megapixel image.

Make prints the same size and with uniform borders. Present them inserted into sleeves in a zippered binder or bound into a custom book with a handsome cover (get portfolio binders at art supply and photo dealers and custom portfolio specialists (see appendix B).

A print portfolio is handsome. If you can show it yourself, excellent. Other-wise, have a "rep" (agent or sales representative) do it for you. But print portfolios are often expensive to make, heavy to ship, and highly susceptible to damage from greasy fingers, spilled coffee, and other perils. You may need several different portfolios to showcase different aspects of your work.

Digital Portfolios

If you don't yet own a film scanner, Kodak and many professional labs make scans from negatives or slides at reasonable prices. Scanned images or digital originals are then uploaded to a computer, so that they can be retouched and "tweaked" (manipulated) in Photoshop (the industry standard retouching program) for printing digitally or uploading to the Internet. Such images can be e-mailed to prospects, placed on a Web site, or both.

Disk Portfolios

Many photographers now show their portfolios and ship them to clients on a computer disk (all commercial users of photography have computers today). I even send out high-resolution scans of images intended for commercial reproduction on disk, rather than risk sending irreplaceable original slides. The images in this book were sent by me to the designer on disk; he made the final adjustments needed for commercial printing.

"Zip" disks are the easiest to use. Insert a 100 MB Zip disk into the necessary Zip drive, and then save files of up to 100 MB onto disk. If you are working on a Mac, you can just drag these files

DSCF0099.jpg DSCF0100.jpg DSCF0102.jpg DSCF0103.jpg DSCF0106.jpg

DSCF0107.jpg DSCF0109.jpg DSCF0110.jpg DSCF0111.jpg DSCF0112.jpg

DSCF0114.jpg DSCF0115.jpg DSCF0116.jpg DSCF0118.jpg DSCF0119.jpg

DSCF0120.jpg DSCF0124.jpg DSCF0125.jpg DSCF0128.jpg DSCF0129.jpg

DSCF0130.jpg DSCF0132.jpg DSCF0135.jpg DSCF0137.jpg DSCF0141.jpg

DSCF0142.jpg DSCF0143.jpg DSCF0145.jpg DSCF0146.jpg DSCF0147.jpg

A contact sheet made by the Adobe Photoshop program and printed on an inkjet printer. For detailed instructions on how to do this, refer to Adobe Photoshop Elements or Photoshop Limited Edition.

to the Zip disk icon. Viewers with a Zip drive can then view your portfolio. A Zip drive now costs under $100 and Zip disks less than $10 each.

To make your own CD-ROM discs requires a "burner." Good burners can be had for a couple of hundred dollars or so. Mine is a Yamaha. The writable CD-ROM disks themselves cost less than $1 each with jewel case and currently hold 600 MB of data.

CD-ROM disks are now the standard for backing up computer data files of all kinds. Most new computers incorporate a CD-ROM player that can show pictures.

Marketing Photographs

It has always been my experience that networking and making personal contact with as many people as you can is the best way to get paid assignments. People like to work with photographers they feel they can trust. This is especially true for photographers starting out. If and when you get "hot" and your name gets around, people you never heard of will call you to do jobs. That is the best possible position to be in. Somewhere between being a beginner and an in-demand photographer, you may wish to advertise, send out mailers, take ads in photography "sourcebooks," and more.

To begin networking, just ask everyone you know for introductions to possible buyers of photography, be they the local newspaper's picture editor, a florist who does a lot of weddings, a third cousin who is a magazine art director or corporate communications director. Practically all businesses have functions that need to be photographed; so do schools and colleges, hospitals, politicians, and tourist attractions.

In smaller markets, photographers tend to be generalists who handle most types of job. In big cities, professionals tend to specialize, in advertising illustration, catalog, still life, photojournalism, news, architecture, fashion and beauty, celebrities and entertainment, annual reports, portraiture, weddings, and more.

This shot was made with strobes to imitate sunlight by shining three heads through a white sheet. Exposure was 1/60 at f/11.

Appendices

A Troubleshooting — Some Lighting Problems and Some Solutions

Lighting problems can occur with lighting equipment not functioning, or they can show up as problems on slides, prints, negatives, or digital images.

Problem: Flash does not fire.
Solutions: (1) Make sure flash is firmly seated on camera hot-shoe. (2) Change batteries. (3) Check that synch cords or remote TTL cords are properly attached to both flash and appropriate camera outlet. (4) Synch cords are prone to problems, so carry a spare.

Problem: Flash recycles very slowly.
Solution: Batteries are low. Change batteries or battery pack.

Problem: Flash or strobe images are blacked out or dark on one side.
Solution: Camera shutter speed is set too high for flash and strobe synch. Set synch speed, or any speed below synch, on the camera.

Problem: Flash or hotlight images are dark, underexposed.
Solutions: (1) The flash ready-light is coming on before the flash is fully recycled. Allow a couple of extra seconds between flashes. (2) Do not exceed maximum flash range. (3) Bring hotlights closer to subject. (4) Check that correct film ISO speed is set on camera. (5) Set digital camera to a higher ISO speed. (6) Use faster film, especially if shooting with a slow telephoto or zoom lens. (7) If underexposure still occurs after doing relevant things from the list above, have your built-in or handheld exposure meter checked out.

Problem: Images are light, overexposed.
Solutions: (1) Do not work closer than minimum flash range. (2) Set higher-number f-stop (lens aperture) with flash or strobe. (3) Use slower film or lower digital ISO setting with hotlights. (4) Use lower shutter speed or smaller aperture with hotlights. (5) Move hotlights or strobe heads further from subject. (6) Put a "neutral density" filter over your lens or over a flash or strobe head.

Problem: Flash pictures of people have unpleasant red pupils, or gray pupils in black-and-white shots. Pets have green, purple, or gray pupils.
Solutions: (1) Try the camera's Redeye Reduction mode, if available. (I do not have much luck with this!) (2) To minimize redeye caused by flash reflecting off the retina of the eye, the best solution is to raise a detachable flash high on a bracket. Off-camera TTL or automatic flash must be connected to the camera with an appropriate TTL or automatic remote cord. An off-camera manual flash can be connected to the camera by a synch/pc cord or by an on-camera trigger plus a slave unit on the flash.

Problem: Indoor or night flash pictures of light-skinned faces against dark backgrounds are overexposed.
Solutions: (1) Move in close to meter. Hold the exposure with the "memory lock" button, if available, or by holding the shutter depressed halfway down, then pull back to reframe the composition. (2) Use an adjustable flash's "select" or "set" mode to *reduce* the amount of flash fill (see flash manual). (3) Set Slow Synch flash mode on your camera (see camera and flash manuals).

A WISE PRECAUTION WHEN SHOOTING WITH STROBES

Avoid potentially serious, expensive repair problems when shooting with an electronic camera and strobe. High-voltage synch signals from strobes can damage delicate camera circuits. If using any electronic camera combined with a synch/pc cord to fire a strobe, be safe. Set a Wein Safe Synch device (about $45) on the camera hot-shoe. Plug the synch cord into that before plugging the other end into the strobe power pack.

Problem: Daylight and flash pictures of dark-skinned people against bright backgrounds are underexposed.

Solutions: (1) See solution 1 immediately above. (2) See solution 2 immediately above, but *increase* the amount of flash fill. (3) See solution 3 immediately above. (4) Avoid posing people against mirrors or other highly reflective backgrounds.

Problem: Flash prints and slides have underexposed or black backgrounds

Solutions: (1) Try the Slow Synch flash mode with a TTL camera and flash (see camera manual); or with a manual camera, try setting slower-than-synch shutter speeds and using an automatic flash as "fill" light. (2) Make sure no unwanted people or objects are between you and your main subject—these cause the automatic flash to cut off light prematurely.

Problem: Photographs of shiny objects, artwork, and so forth have objectionable hotspots.

Solutions: (1) Do not aim lights direct. Diffuse or bounce light, so that it falls softly onto the subject. (2) Work in a darkened room or at night and wear dark clothes to avoid unwanted reflections or existing light affecting your subject.

Problem: Close-ups made with a flash are consistently overexposed.

Solutions: (1) With a built-in flash, set the smallest possible f-stop on the lens. Do not exceed minimum flash range, or the unit will not have time to cut off light before overexposure. (2) For extreme close-ups, use a detachable flash on a bracket. Set the flash to manual mode. Use a handheld light meter to set exposure.

Problem: Close-ups made with a pop-up flash have a half-moon-shaped shadow in the frame.

Solution: Do not use a big or long lens with a pop-up flash. Such lenses can cast a shadow on your images.

Problem: Strobe will not fire.

Solutions: (1) Make sure that the AC cord is attached both to "mains" AC outlet and to the strobe power pack. (2) Check that the power pack and individual strobe heads and modeling light switches are turned on. (3) If firing the strobe with a sync/pc cord, make sure it is attached to both strobe and camera. (4) If firing strobes with a trigger/slave combination, make sure both are firmly seated on camera and power pack. (5) If using a "channeled" trigger/slave combination, make sure both components are operating on the same channel. (6) If you have been shooting very fast, the strobe may need a cooling-off period. (7) The synch cord can have a problem; try another, and always have a spare on hand.

Problem: Strobe pictures have a black or dark band down one side.

Solution: The camera was set at too high a synch speed. Set the shutter to maximum flash synch speed or at any speed below synch speed.

B Manufacturers and Lighting Resources

Film and Digital Cameras and Flash Systems

Bronica: *www.tamron.com*

Canon: *www.usa.canon.com*

Contax: *www.contaxcameras.com*

Fuji: *www.fujifilm.com*

Hasselblad: *www.hasselbladusa.com*

Leica: *www.leicacamera.com*

Mamiya: *www.mamiya.com*

Minolta: *www.minoltausa.com*

Nikon: *www.nikonusa.com*

Olympus: *www.olympus.com*

Pentax: *www.pentax.com*

Rolleiflex: *www.rollei-usa.com*

Light Stands, Tripods, Clamps, and Booms

Avenger: *www.bogenphoto.com*

Calumet: *www.calumetphoto.com*

Gitzo Tripods: *www.bogenphoto.com*

Lowel Stands and Accessories: *www.lowel.com*

Manfrotto: *www.bogenphoto.com*

MSE (formerly Matthews): *www.mse.grip.com*

Red Wing Booms: *www.bkaphoto.com*

Smith-Victor: (800) 345-9862

Hotlights and Accessories

Bulb Direct Replacement Lamps:
www.bulbdirect.com

Hotlights: *www.hotlights.com*

Lowel: *www.lowel.com*

MSE (formerly Matthews): *www.mse.grip.com*

Smith-Victor: (800) 345-9862

Starlite: *www.photoflex.com*

Independent Flash Manufacturers

Ikelite Underwater Flashes:
www.ikelite.com

Metz/Mecablitz: *www.bogenphoto.com*

Morris Mini Lite Self-Slaved Flashes:
www.morriscompany.com

Sunpak: *www.tocad.com*

Vivitar: *www.vivitar.com*

High-Powered Portable Flashes

Comet (*See* Dyna-Lite, *under Strobe Systems*)

Elinchrom: *www.bogenphoto.com*

Hensel: (800) 4HENSEL

Lumedyne: *www.lumedyne.com*

Metz/Mecablitz: *www.bogenphoto.com*

Quantum: *www.qtm.com*

Sunpak: *www.tocas.com*

Visatek: *www.hasselbladusa.com*

Strobe Systems

Balcar: *www.calumetphoto.com*

Broncolor: *www.sinarbron.com*

Calumet: *www.calumetphoto.com*

Comet (*See* Dyna-Lite)

Dyna-Lite: *www.dyna-lite.com*

Elinchrom: *www.bogenphoto.com*

Hensel: (800) 4HENSEL

Novatron: *www.novatron.com*

Photogenic: *www.photogenicpro.com*

Profoto: *www.profoto-usa.com*

Speedotron: *www.speedotron.com*

White Lightning:
www.white-lightning.com

Custom Synch/PC Cords

Paramount: *www.paramount.com*

Trigger and Slave Systems

Ikelite Lite-Link: *www.ikelite.com*

Pocket Wizard: *www.pocketwizard.com*

Quantum: *www.qtm.com*

Wein: *www.weinproducts.com*

Rechargeable Battery Packs

Lumedyne: *www.lumedyne.com*

Quantum: *www.qtm.com*

Sunpak: *www.tocad.com*

Underdog: *www.underdog-battery.com*

Handheld Exposure Meters

Gossen: *www.bogenphoto.com*

Minolta: *www.minoltausa.com*

Sekonic: *www.sekonic.com*

Wein: *www.weinproducts.com*

Miscellaneous Lighting Accessories

Chimera: *www.chimeralighting.com*

LumiQuest: *www.lumiquest.com*

Photoflex: *www.photoflex.com*

ProTech: *www.protech.com*

Rosco: *www.rosco.com*

Sto-fen: *www.stofen.com*

Professional Flash and Strobe Repair

Flash Clinic: *www.flashclinic.com*

Mail Order Catalogs

B & H Photo Video: *bhphotovideo.com*
Calumet: *www.calumetphoto.com*

Film and Digital Media

Eastman Kodak: *www.kodak.com*

Fuji: *www.fujifilm.com*
Ilford: *www.ilford.com*
Lexar: *www.digitalfilm.com*
Polaroid: *www.polaroid.com*
3M: *www.3m.com*

Bags and Cases

Pelican: *www.bkaphoto.com*
Tenba: *www.tenba.com*

C Lighting Setups for the Full-Page Photos

Page i: A high-key portrait of Christopher. I asked the boy's mother to dress him in white. I shot with my Fuji S-1 digital camera, which has a minimum ISO setting of 400, and used a 28–80 mm zoom lens at about 50mm. When lighting for film for a high-key look, I always bracket (vary) my exposures. With digital images like this one, I have learned by experience that you must never overexpose, or the detail in the highlights will be lost without hope of recovery, even with the aid of Adobe's marvelous Photoshop program. Moderate underexposure is easily correctable. For this shot, I took readings with an incident-light meter and played back test images on my computer before achieving the result I wanted. Lighting was two 300 WS monobloc strobe units. (See page 137 for details on this type of setup). A 3 × 6 foot white reflector on the left provided additional fill. Exposure was 1/60 at f/16.

Pages ii–iii: Mannequin heads. See pages 43 and 46.

Page vi: Still life of tin cans. I set up the antique cans and bounced light down onto them with one strobe head aimed at a 4 × 8 foot white Fome Cor sheet used as a reflector. The light was three feet away and six feet high. The reflector was about six feet away from the cans and gave an almost shadowless daylight effect. The 500 WS strobe unit was cut to half power. Exposure was 1/60 at f/11 on ISO 400 film.

Page viii: Two wine glasses against a black background. Shown here, "edge lighting" against a black background is achieved with one 300 WS strobe bounced into a forty-inch black-backed umbrella used as the main light. A white fabric reflector, hung opposite the main light, provided fill. Work in a darkened room or at night to eliminate unwanted reflections. For more information on working with glass, see pages 96 and 110.

Page x: To get sufficient depth of field (zone of sharp focus) in the lobby of the State Capitol in Trenton, New Jersey, I chose an aperture of f/8. The in-camera meter indicated that a long exposure of 1/2 was required at an ISO 400 digital camera setting. I activated my Fuji S-1 camera's pop-up TTL flash to illuminate the close, dark archway—it balanced the existing lighting perfectly. Essentially, I was using slow-synch flash, but it was set manually. The camera was on a tripod.

Pages xii–1: Miriam Navalle at her T-Salon restaurant in New York. This interior was lit with strobe. For details see page 84.

Page 2: This setup shot was made in a London restaurant with two 500 watt Lowel Omni quartz lights fitted with bulbs compatible with Britain's standard 220 volt AC current—no transformer is needed with the Omnis, which makes them great for travelers. One light was aimed from about five feet off-camera at viewer right. The second was hidden low behind the third waiter and aimed slightly up at the right wall. On ISO 50 film, exposure was 1/15 or 1/8 (I bracketed exposures) at f/11 with a 20mm lens and camera on a tripod.

Pages 20–21: This portrait of a friend was made with a 500 WS strobe aimed through a 36 × 48 inch Chimera soft light bank. The light was about four feet from the subject, and the room was in total darkness otherwise. I wanted to emphasize the planes of the face. Exposure was 1/60 at f/16.

Page 22: Caroline with raised hand. I used the same lighting as for the portrait on page 16. This image originally faced left; for the book it needed to face right, so I "flopped" (reversed) it.

Pages 31–31: Lighting Hanukkah candles. A 3,200°K photoflood lamp was screwed into a household standing lamp and used bare-bulb across the room to reduce overall contrast but not overpower the lighting mood created by the candle and match flames. I put a $2 ceramic insert between bulb and light fixture for safety. Exposure with ISO 1,600 film was 1/30 at f/2.8.

Page 32: A 500 watt quartz Lowel Omni light bounced off the wall gave enough fill light for a good portrait of this elderly lady living alone in a single-room occupancy hotel. I chose it both for its inherently soft quality and to avoid having bright strobe flashes upset the frail subject, who was ninety-five years old. I used a 35mm f/1.4 lens. Exposure was 1/60 at f/4 on ISO 50 film.

Pages 38–39: Engraved invitations. A still life made for the Artscroll Printing Corporation. For information on how I approach "high-key" shots, see pages 136–137.

Page 40: Thomas Wolfe's room, Asheville, North Carolina. One 500 watt Smith-Victor quartz light bounced out of an umbrella, out of frame at right, lit the interior of the room. With my Nikon FM-2 manual camera and 20 mm f/2.8 lens on a tripod, I first placed books and Wolfe relics while constantly checking their position as seen through the lens. With the aid of an incident-light meter, I then moved the light back and forth until foreground books and background furniture (lit by daylight through the window) were evenly lit. On ISO 100 film, basic exposure was ⅛ at f/16. (I bracketed exposures as well.)

Pages 50–51: The historic Coney Island Carousel was backlit by bright daylight. With my Fuji S-1 digital camera's TTL meter, I aimed at the high windows to get a background exposure; it was 1/60 at f/4 with an ISO 400 digital setting. To record background as blur, I chose the equivalent exposure of ⅛ at f/11, turned on my flash in TTL mode, and "panned" to follow the movement of the carousel. The brief burst of light from the flash alone lit the horse and riders in front, freezing their motion. This was my favorite of about forty shots.

Page 52: A manually set, handheld Nikon N-90 and an on-camera Nikon SB-26 flash in TTL mode were aimed at a tombstone in a Brittany cemetery at twilight. Exposure with ISO 100 film was 1/30 at f/11.

Pages 76–77: Multitalented actor, gymnast, and mime Sal Brienik. For information on how this shot was taken, refer to more photographs of Sal on page 126.

Page 78: Fortune teller. See page 141 for details.

Pages 88–89: A group of Santas who collect money for charity each Christmas in New York. I used just a touch of flash fill to brighten the whites of beards, belts, and hats on an extremely gloomy December morning. Exposure was 1/60 at f/5.6 on ISO 100 film, with my TTL flash fill setting at minus one f-stop.

Page 90: Refer to the caption on page 91.

Pages 122–123: Michael and umbrella. One 500 watt Smith-Victor quartz light was bounced out of a forty-eight-inch silver umbrella placed at the high three-quarter position to camera left. A big umbrella used up close "wraps" a subject in soft light. I wanted some delineating shadow so did not add a reflector or fill light. Digital exposure was by in-camera meter; I mounted the camera on a tripod and set shutter speed to 1/60. (F-stops were bracketed.)

Page 124: Two musical girls. One TTL flash mounted on a six-foot light stand effectively lit this shot. The flash was attached to the camera with a TTL cord. Soft light bounced out of a twenty-four-inch silver umbrella shone down on the girls. The exposure was set to 1/15 at f/5.6. The flash in TTL mode was the main light. A low-wattage household lamp plus a self-slaved mini-flash just out of frame gave some extra fill on the right.

Pages 148–49: A worktable still life in my studio. One 500 watt photoflood lamp used bare bulb lit this shot. Note the distinct but weak shadows. Also note the old Polaroid 110B camera that I still use to test shots made on film. (It has been modified to accept current Polaroid film backs.) I metered through the lens with my 3 MB digital camera set on a tripod, but did not record the exposure.

Page 150: Hampton Court and courtier. On a wintry London day I metered with my Nikon N-90 with 20mm lens, manually underexposing the background by ½ f-stop. Then, with my on-camera SB-26 flash in TTL mode, I reduced the TTL flash fill by 0.7 (⅔ of an f-stop) with the select/set button. I was about four feet from the subject; the fill was softened with a Sto-Fen dome over the flash head. See your adjustable flash's manual for more.

Pages 154–155: Antique tools. An adjustable, on-camera 120 GN flash set to TTL mode was aimed straight up at a ten-foot white ceiling, so soft-bounce flash lit the picture. Manually set exposure on the digital camera was f/16 at 1/60 for ISO 400 speed. I used a 28–80mm zoom lens and handheld the camera.

Index

Books from Allworth Press

Mastering the Basics of Photography
by Susan McCartney (paperback, 6¾ × 10, 192 pages, $19.95)

Travel Photography, Revised Edition
by Susan McCartney (paperback, 6¾ × 10, 360 pages, $22.95)

Business and Legal Forms for Photographers, Third Edition
by Tad Crawford (paperback, with CD-ROM, 8½ × 11, 192 pages, $29.95)

The Business of Studio Photography, Revised Edition
by Edward R. Lilley (paperback, 6¾ × 9⅞, 336 pages, $21.95)

ASMP Professional Business Practices in Photography, Sixth Edition
by the American Society of Media Photographers (paperback, 6¾ × 10, 416 pages, $29.95)

Photography: Focus on Profit
by Tom Zimberoff (paperback, 8 × 10, 432 pages, $35.00)

Pricing Photography: The Complete Guide to Assignment and Stock Prices, Third Edition
by Michal Heron and David MacTavish (paperback, 11 × 8½, 160 pages, $24.95)

How to Shoot Stock Photos That Sell, Third Edition
by Michal Heron (paperback, 8 × 10, 224 pages, $19.95)

The Photographer's Internet Handbook, Revised Edition
by Joe Farace (paperback, 6 × 9, 232 pages, $18.95)

Re-Engineering the Photo Studio: Bringing Your Studio into the Digital Age
by Joe Farace (paperback, 6 × 9, 224 pages, $18.95)

The Photographer's Assistant, Revised Edition
by John Kieffer (paperback, 6¾ × 9⅞8, 256 pages, $19.95)

The Photojournalist's Guide to Making Money
by Michael Sedge (paperback, 6 × 9, 256 pages, $18.95)

Mastering Black-and-White Photography: From Camera to Darkroom
by Bernhard J Suess (paperback, 6¾ × 10, 240 pages, $18.95)

Historic Photographic Processes: A Guide to Creating Handmade Photographic Images
by Richard Farber (paperback, 8½ × 11, 256 pages, $29.95)

Photography Your Way: A Career Guide to Satisfaction and Success
by Chuck DeLaney (paperback, 6 × 9, 304 pages, $18.95)

Please write to request our free catalog. To order by credit card, call 1-800-491-2808 or send a check or money order to Allworth Press, 10 East 23rd Street, Suite 510, New York, NY 10010. Include $5 for shipping and handling for the first book ordered and $1 for each additional book. Ten dollars plus $1 for each additional book if ordering from Canada. New York State residents must add sales tax.

To see our complete catalog on the World Wide Web, or to order online, you can find us at *www.allworth.com*.